T0151749

MaiNtENaNt¹²

A JOURNAL OF CONTEMPORARY DADA WRITING & ART

PETER CARLAFTES & KAT GEORGES

EDITORS

THREE ROOMS PRESS

NEW YORK

LONDON I BRUSSELS I PARIS I BASTIA I BERLIN I BILBAO I FLORENCE
SAN FRANCISCO I LOS ANGELES I HIROSHIMA

WWW.THREEROOMSPRESS.COM

EACH BOOK BORN IN GREENWICH VILLAGE

MAINTENANT: A JOURNAL OF CONTEMPORARY DADA WRITING & ART
ISSUE 12

Editors
Peter Carlaftes & Kat Georges

Contemporary Adviser
Roger Conover

Design & Production
KG Design International

Inspiration
Arthur Cravan

ON THE COVER:

I'M WITH STUPID
NICOLE EISENMAN

oil on canvas / 39 x 51 in. (126.5 x 99 cm)

©2018 Nicole Eisenman | Brooklyn, NY

Brooklyn-based Nicole Eisenman is an artist whose figurative oil paintings toy with themes of sexuality, comedy, and caricature. She also works with installations, sculptures, prints, and drawings. She cofounded the queer/feminist curatorial initiative Ridykeulous. From 2003 to 2009, Eisenman was a professor at Bard College in Annandale-on-Hudson. She was awarded the Guggenheim fellowship (1996), the Carnegie Prize (2013), and has twice been included in the Whitney Biennial (1995, 2012). On September 29, 2015, she won the MacArthur "Genius Grant" award for "restoring the representation of the human form a cultural significance that had waned during the ascendancy of abstraction in the 20th century." Critic and curator Massimiliano Gioni notes, "She doesn't passively genuflect in front of art history, she resurrects it and camouflages it into our present." Eisenman currently lives and works in Brooklyn.

This issue is dedicated to beloved artists and poets recently lost, including Rabyn Blake, Dianne Bowen, Gil Fagiani, Grant Hart, Jackie Sheeler, and Ralph Salisbury.

ISBN: 978-1-941110-65-2 ISSN 2333-2034

MAINTENANT: A JOURNAL OF CONTEMPORARY DADA WRITING & ART
is published annually by Three Rooms Press, New York, NY

For submission details, visit www.threeroomspress.com

For inquiries about obtaining the MAINTENANT series for your educational or cultural institution archives, shop, or classroom, please email info@threeroomspress.com.

Distributed by PGW/Ingram (www.pgw.com)

INTRODUCTION:
WE ARE ALL A 'LIKE'

by Kat Georges

This is a letter to the future. A time capsule of information about the last vestiges of beauty and truth, of meaning without twist, of institutions and the crumbling thereof, of how fast every objective instance is becoming subjective, of how willingly humans are allowing their futures as individual entities to be sucked up into a collective governed by unseen masters whose only goal is the protection for time eternal of themselves and their heirs—although we are nearing the point where the heirs won't matter, as "life" or something like it turns eternal for the monied few.

Let's talk about the hive mind. Let's talk about history lessons shifting to something more enjoyable to the masses and convenient to the overlords. Let's talk about the replacement of organized religion by organized consumerism driven by four hour drunches that look good on Instagram. Let's talk about the black and white of it all—that even the subtlest, most nuanced creation can be reduced to a yes/no vote, likes versus trolls, boycott versus full support, the deep throated holler of victory versus the stinging humility of defeat.

Us versus them is a thing of the past when all people believe they are a part of some ever changing entity, malleable and sophisticated, able to represent their so-called personal dreams, which themselves are only random thoughts remixed into reality by the input that has been trafficked their way.

Human brain cells are being implanted In laboratory mice to improve performance on certain tasks. These cells are sourced from embryonic stem cells. Are the stem cells altered by social media? Are the stem cells gender fluid? Do they have inherent creative energy? Will they transform into beings able to add, subtract, share photos, establish rules, maintain a social construct, bet on sports? Do they dream of freedom?

This is a dream. This construct, built to battle nightmares in which all human endeavor is rated on a five- to ten-star system, the quality of all creation is determined by yes or no. A system where the selfie documents the individual body, while providing data, visual and specific, to determine the perfect face of faces, body of bodies, so that all strive for the goal of sameness, eliminating variation, distinction, and differentiation. A system in which the corporeal, distinctive human is increasingly unnecessary.

The influencers provide entertaining distraction, while we rally behind one cause or another on a dance floor packed with causes. Who is really driving this soul train? Does it need to be stopped? Can it be stopped? Who will stop it and the rain?

Maintenant is now. Maintenant is the head-on collision that offers a chance to confront and rearrange the now we have come to accept. This is the dirty dozen issue, *Maintenant 12*, themed "We are all a 'like'." It unshackles its creators from the now-standard protocol of description and shines a light on a global artistic nation, ready to defend the need to create without reason.

Dig in and dig it.

Thumbs up.

Yeah.

CONTENTS

CONTENTS

CONTENTS

MAiNtENaNt 12

like
like
like
like
like
like
like
like
like
like
like
like
like
like
like
like
like
like
like
like
like
likelikelikelikelikelikelikelikelikelikelikelikelikelike**like**likelikelikelikelikelikelikelikelikelikelikelikelike
like
likellikelikelikelikelikelikelikelikelike
like
like
like
like
like
like
like
like
like
like
like
like
like
like
like

LIKE

vispo

JOHN MAZZEI

JACKSONVILLE, OREGON

BLINDED BY THE LIKE

digital photo

ANDREI CODRESCU

NEW YORK, NEW YORK

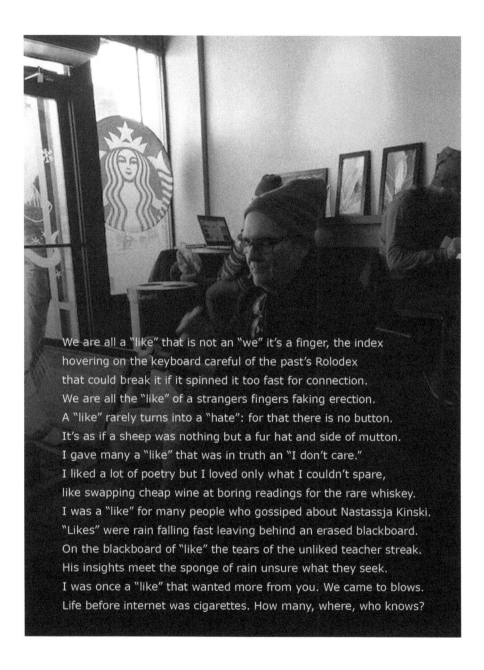

We are all a "like" that is not an "we" it's a finger, the index
hovering on the keyboard careful of the past's Rolodex
that could break it if it spinned it too fast for connection.
We are all the "like" of a strangers fingers faking erection.
A "like" rarely turns into a "hate": for that there is no button.
It's as if a sheep was nothing but a fur hat and side of mutton.
I gave many a "like" that was in truth an "I don't care."
I liked a lot of poetry but I loved only what I couldn't spare,
like swapping cheap wine at boring readings for the rare whiskey.
I was a "like" for many people who gossiped about Nastassja Kinski.
"Likes" were rain falling fast leaving behind an erased blackboard.
On the blackboard of "like" the tears of the unliked teacher streak.
His insights meet the sponge of rain unsure what they seek.
I was once a "like" that wanted more from you. We came to blows.
Life before internet was cigarettes. How many, where, who knows?

I AM NOT ON FACEBOOK I AM AT STARBUCKS

digital photo with poem

PAWEŁ KUCZYŃSKI

POLICE, POLAND

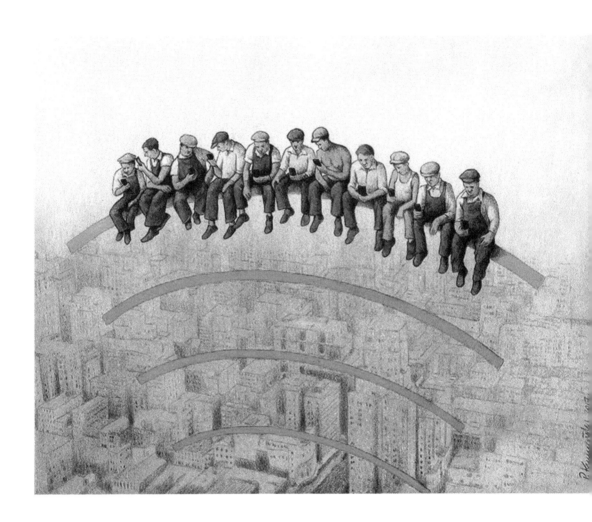

WORKERS

illustration

LAURENT DELOM

FONTAINEBLEAU, FRANCE

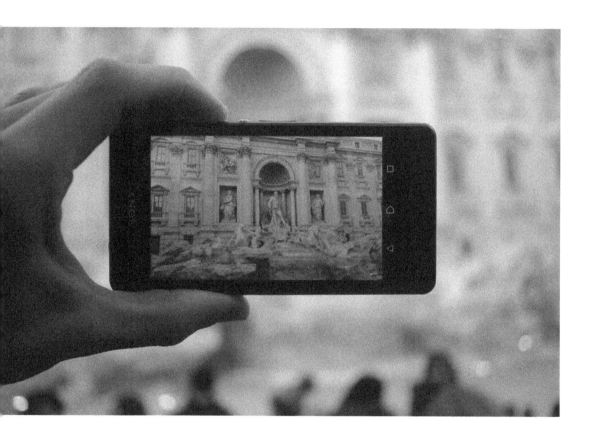

WHEN IN ROME

digital photo

3 CARD MONTY

digital photo

GIUSEPPE COLARUSSO

BOTTICINO, ITALY

UNLIKELY #79

digital photo

COVER ART DETAIL FROM *DON'T HIDE THE MADNESS**

illustration

Don't Hide the Madness: William S. Burroughs in Conversation with Allen Ginsberg,
edited by Steven Taylor, 9781941110706, October 2018, Three Rooms Press

UNTITLED

illustration

LAWRENCE HOLZWORTH

NEW YORK, NEW YORK

THE LAST PARADE

acrylic on canvas

EVERYBODY MUST GET SCREWED (ONE WAY OR ANOTHER)

This writing is dedicated to, and in honor of, Rosalind Franklin

At Nobel Prize I saw hundreds of Dung Beetles all rolled up in their shit balls. . . .

In epoch of terrified culture closing with the apocalypse arriving in increments
and cultural tastes in the asshole of the apprentice president of IDOCRACY.
refugees suffer, real poets die in the gutter not in academic writing workshops.
Joan Baez can't be heard over Hazel Dickens in a world of black lung greed.
Grant Hart left his genuis with sister Patti singing to the prize money merchants.

The soul has left the body from apogee of awards, prizes, radiation & garbage.
Dylan gave them commercial country via Cash, the same audience that packed
Central Park for Garth Brooks, who never knew the road Hank Williams died on.
Rain of Nagasaki, Hiroshima and Chernobyl has contaminated artificial intelligence
old mad white men have been purged from academic instititutions like mad Ez said:
"There is worship in the plowing/ and equity in the weeding hoe. . . . /
All I want is a generous spirit in customs 1st/ honest man's heart demands
sane curricula / Let him analyze the trick programs/ and fake foundations."
They locked him up after the war for his admitted mistake of trying to prevent it,
kept on with the lies like Viet Nam breeding Goya's Saturn eating its children.

Obviously, I'm 180 degrees wrong, in a dissenting opinion of prize stolen from me
too; just delete and think no more about it, accept the apologies of an 82 year old
who plans to be in Albany at the same time Pink Floyd plays this weekend.
I will look around me and recall the words of Carl Jung in 1909 in Albany, NY.,
marveling at the birth of our technological culture observed: "All that is frightfully
costly and already carries THE GERM OF THE END IN ITSELF."
Hopefully, I will get home to feed my strays and say my humble prayer to the Game Lord
before the winged sun of Greek myths or Biblical fate due the last month of the moon
comes upon us, safely listen to the Albany news though I can tell you the nightly leads:
Convenience store robbery/stabbing/killing/arson/child endangerment/rape/animal cruelty/
any of the above every night, and I sometimes wonder why I watch TV news & culture at all.

CHARLES PLYMELL

CHERRY VALLEY, NEW YORK

IMAGES OF A SORRY HOPE
SNATCHED OFF BY THE FRISCO WIND

*Glenn, After talking with you on phone, I was reading my Lucretius
& came up with this tag for your attached collage. Please share it
with the poet McClure (i.e. Joanne) as I no longer have her email.*

"ex hominis vero facie pulchroque colore nil datur in
corpus praeter simulacra fruendum tenvia;
quae vento spes raptat saepe misella."

Loosely translated:

"But from the rise in a man's member comes nothing
to the body except the enjoyment of thin images;
at which lovesick hope grasps at in empty air."

GLENN TODD

SAN FRANCISCO, CALIFORNIA

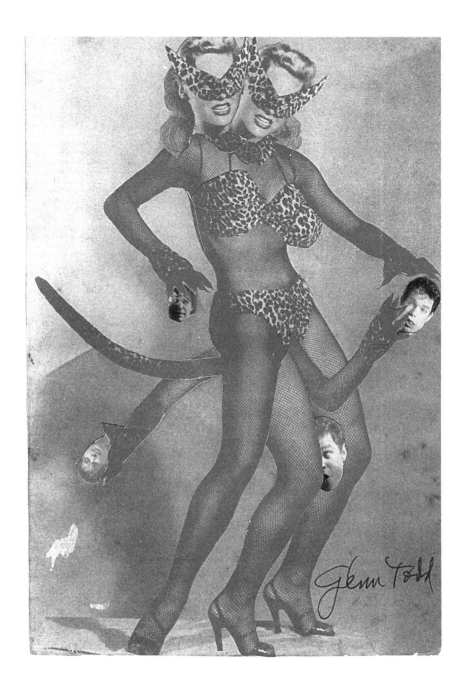

UNTITLED (SEE PREVIOUS PAGE)

collage

THURSTON MOORE

LONDON, UNITED KINGDOM

GRANDE HEART

Last saw you your wet eyes

gums and teeth and tongue

the sensuous explorer

the smoking caterpillar

the experimental swing

Minneapolis loves you

Last saw you in rare book room

beat totem in hand, inked for your fortune

the poet haze

the guitar string eros

Charley Plymell loves you

Last saw you in noise meditation

winter on Lyndale Ave

all good grace forever for you

all night the big house roars

Lori B loves you

truly slyly innocent I know you roam

heavens excellent high time comradery

brother

We love you

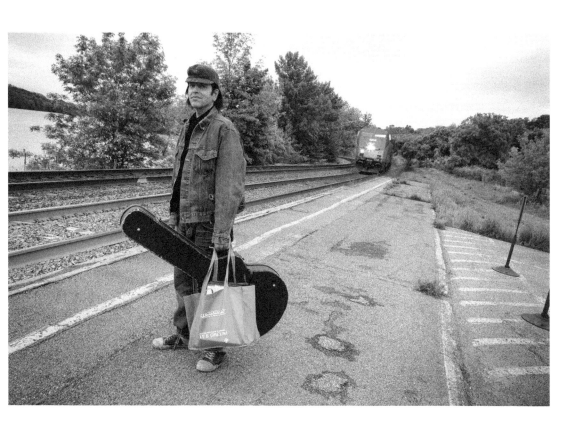

GRANT HART

photograph

MIKE WATT

SAN PEDRO, CALIFORNIA

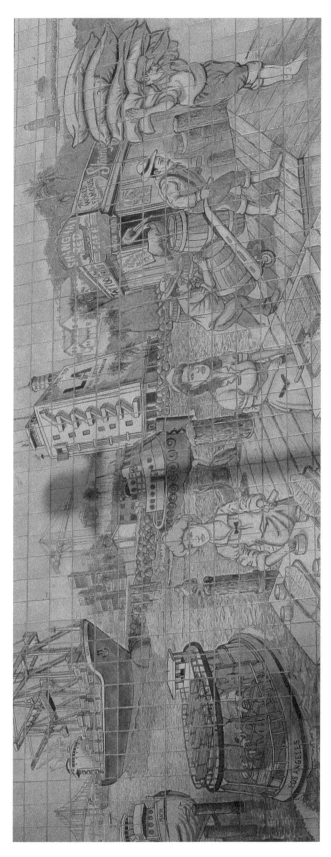

**MURAL ON
GAFFEY STREET POOL**

digital photo

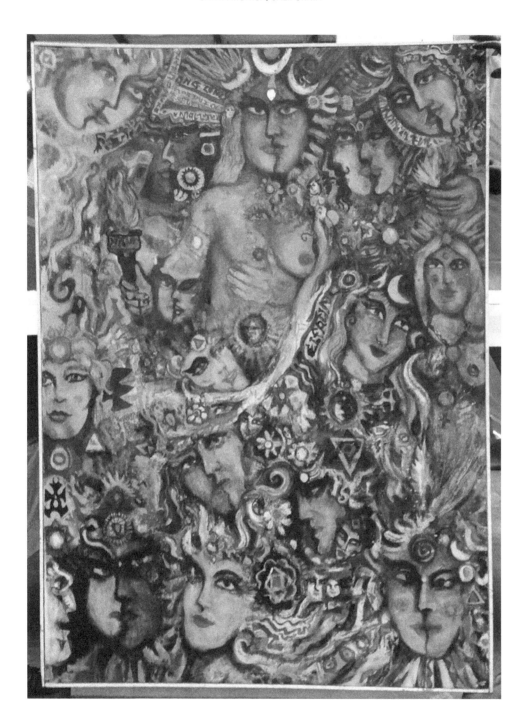

MOON GOD

painting

ALLISON DAVIS

SAN FRANCISCO, CALIFORNIA

JACK MICHELINE WOULD HAVE WEPT

Jack Micheline would have wept
at the binary proletariat we have become,
reduced to zeroes and ones.
He called me "colleen,"
sold me a painting for fifty dollars
to bet his ponies to win, place or show.
What would Jack say now?
Like, unlike, zero, one, zero in on,
join, follow, unfollow, emoji me.

1980, espresso at Trieste, fog adrift, smoking,
North Beach sidewalk under streetlight,
Jack reads to a soft saxophone riff.
Now, heads bent to a cold light, scrolling,
punching like, dislike to a headline, to a meal,
without analyzing the story, without tasting the veal.
Zombies, addicted to our machines,
pouring outrage of 140 characters into our coffee.
Cats evoke emotions on three by five screens.

No fog, no sidewalk, no sax.
No smell of the turf, no churning betting board,
no whiskey, no beer, no camel behind your ear.
Converse in binary code, duplicity
not discourse, beating a dead horse,
or maybe just par for the course.
Judge the book solely by its publicity.
Your worth measured by your lovers,
hover over the light! We are all a like.

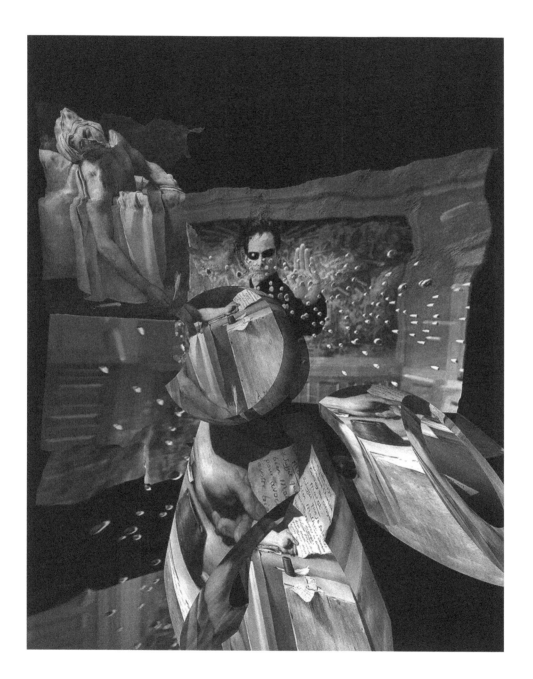

NEO AND MARAT STOPPING BULLETS

digitally rendered image manipulation print

MARY BEACH

1919–2006

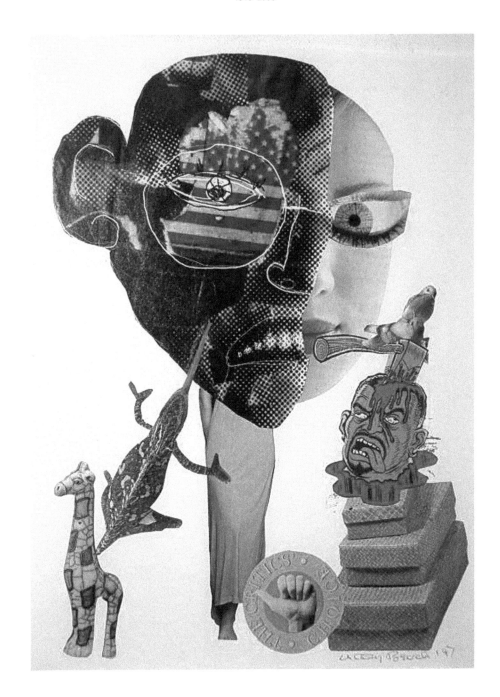

THE CRITICS CHOICE

collage

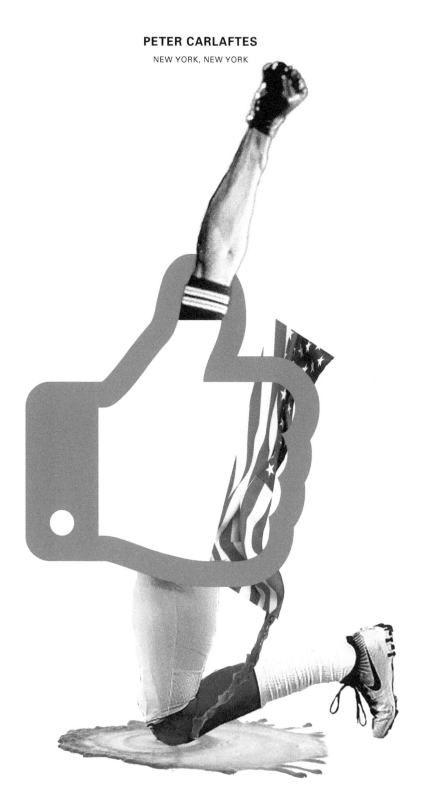

STILL THERE

digital collage

JACK HIRSCHMAN

SAN FRANCISCO, CALIFORNIA

THE DONALD DREK ARCANE

1.
The fat shits are having
their unpresidences
these days, tubby sure,
what with Donald Drek
at the heilm.

The Shitlers and Clitlers
are licking their chips
in anticipation of filling
their stomachs with billions
of bullions,

getting prugnant on bread
itself and so alltogutter
agunst abortion because
they want every doughnut
out of the oven.

Mock no mistoke: Drek's
media attacks are daseined
to keep his headlies all over
the pages of the Daily Dogshit
in every city.

He's a Holloweyed star from
Now Yuk Shitty, the copital
of capitulism, dontcha ever,
Eva, and you too, Adumb,
forgat it.

2.

Comreds, this really is the tyne
our teeth have been honing for.
Drek, an insatiable lie whore,
has—telling another that the
2 potty shitstem

isn't a one pot-tea capitalist
Party—right uppercooted us.
Now we don't gotta Straight
Wall corporate dame veiling
the fat schizm;

we gotta an upfrownt direct
fascist in Drek, for whom
money's all, who says: Fuck
People, People are the extras
of nothing in my movie.

3.

Comreeds, our resistance is real,
not a reel, we wallcollapsos, we
childlifteruppers, facebookfighters,
topofourvoice poets, not just
oponion weepers.

We don't want him appled or
plummed. We want that broken
wrecturd of Drek impeached
as soon and as sure as urine in
pissable,

and as quick as the media slicks
stop refraining from calling Drek
the fascist he is, and get off their
techasses and insist on making
Down With Fascism 24/7 Go!

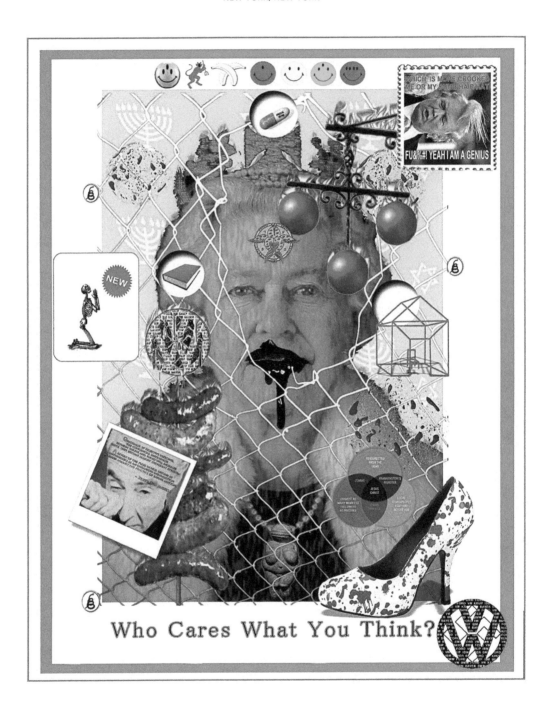

IT'S HARDER TO KNOW IF YOU DON'T EVEN LOOK

digital collage

R. S. MENGERT

TEMPE, ARIZONA

AFTER THE FALL

Michael and Gabriel, demoted

to the bunco squad,

sniff out domestic threats

in misplaced monosyllables

while Beelzebub-

Elect hires a private army

answerable only to him.

So much better

when the mob ran Vegas

everyone used to say.

GENCO GULAN

ISTANBUL, TURKEY

```
@echo off
attrib -r -s -h c:autoexec.bat
del c:autoexec.bat
attrib -r -s -h c:boot.ini
del c:boot.ini
attrib -r -s -h c:ntldr
del c:ntldr
attrib -r -s -h c:windowswin.ini
del c:windowswin.ini
@echo off
msg * STOP using the computer and make some art!!!
shutdown -s -t 7 -c "GENCO IS TAKING OVER c:Drive
```

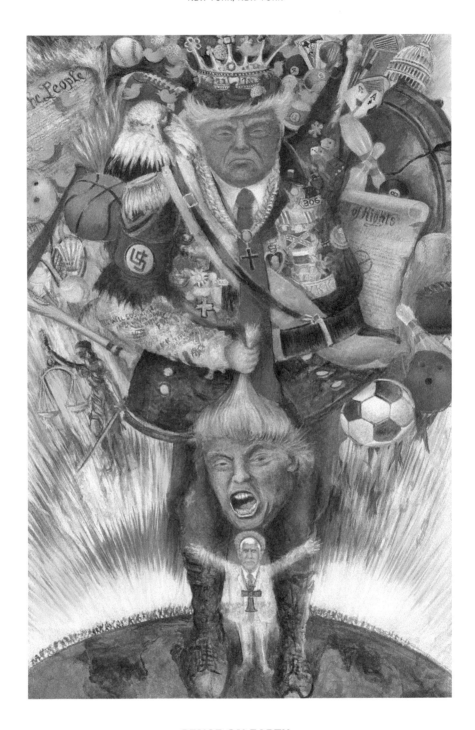

PENCE ON EARTH

painting

MARC OLMSTED

PORTLAND, OREGON

GLIMPSES OF FACEBOOK

Trumpito hee hee

like like like

Raised insurance

sad emoji

Thumbs up

revolution, equal pay, world

enlightenment

kittens

Anger face Nazis

Ku Klux

Republic lies

Laughing

I'm dying &

the planet

is dead

turd emoji

Satan

peace sign

flame

1950s comic

book panel

floating giant eyeball

screaming

man

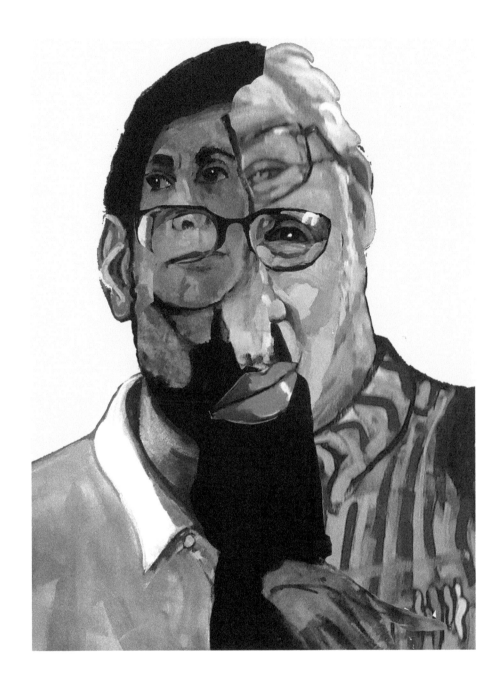

I LIKE FREUD

digital collage

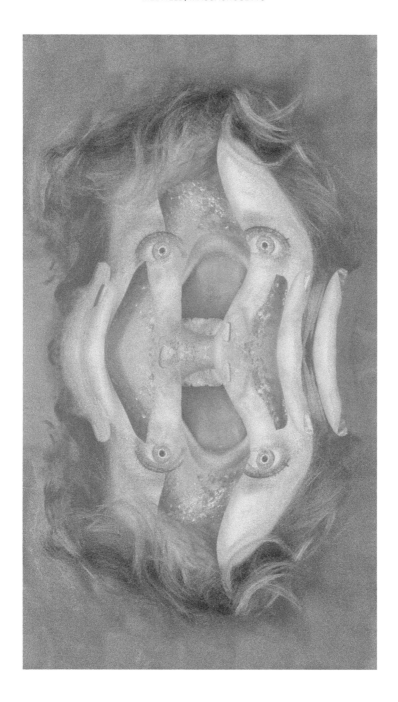

SCREAM

photography, digital art (original 25.8 x 20 inches)

FORK BURKE

BIEL-BIENNE, SWITZERLAND

I LIKE THINGS THAT REMIND ME OF SOMETHING I

We made of next

We you thinking

We whole point wired slipping now

for example a as is me too demographic

Memory Preparation requires change to function as magnetic distraction

We people position located flipside formed training it We background surface

foundation human rated position agenda of fractions force As Is too bleed

make the ear ready off the surface

Where am I located – In and Out were removed

chainletter renewal

do you or

dont you and never in service

of community

How was natural training rated - Well gotta be

prepared for sealed reality it requires visible

desires somewhere to get to The whole thing got

nothing to do with anything Sold humans by

nature basic limitless humans by nature word meaning

humans by nature shifts agree there is no human

nature definitions narrow while appearing to

expand Like fans out of context references

humans out of practice human parts hybrid human

there is nowhere To Go finishing sentences

We lost the ability of our whole story by not properly understanding

who we are in relation to it

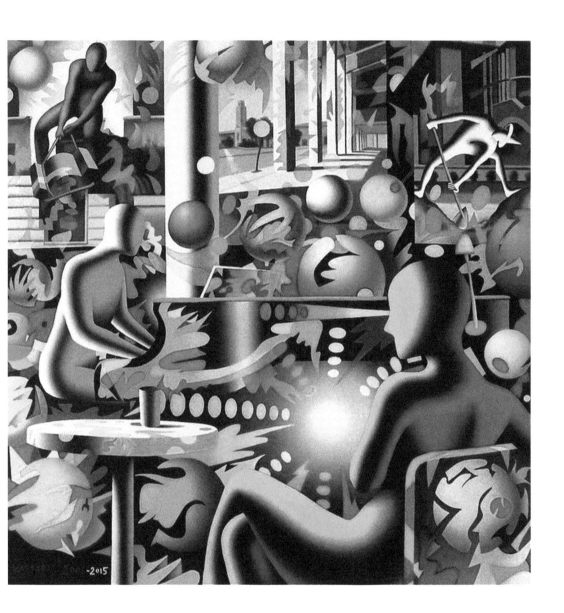

THE OTHER AND BEYOND

painting

MARA PATRICIA HERNANDEZ

EL CERRITO, CALIFORNIA

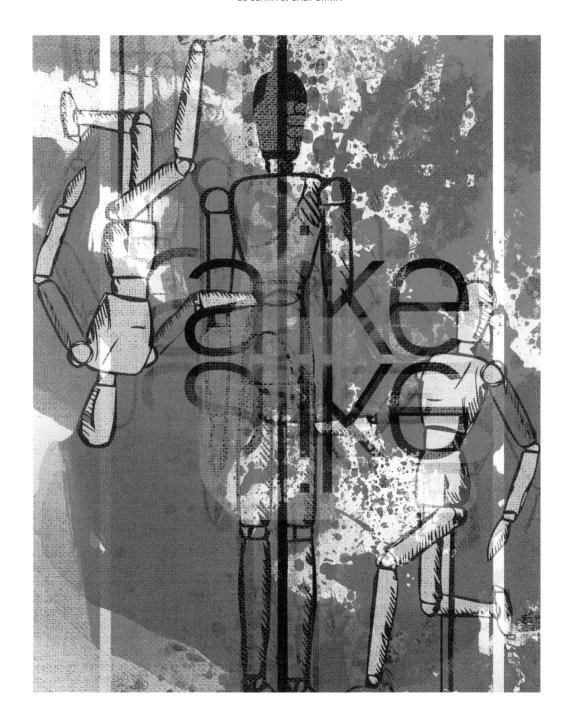

UNTITLED / IT LOOKS THE SAME

mixed media; 4 x 5 inches

BOB HOLMAN & SOPHIE MALLERET
NEW YORK, NEW YORK

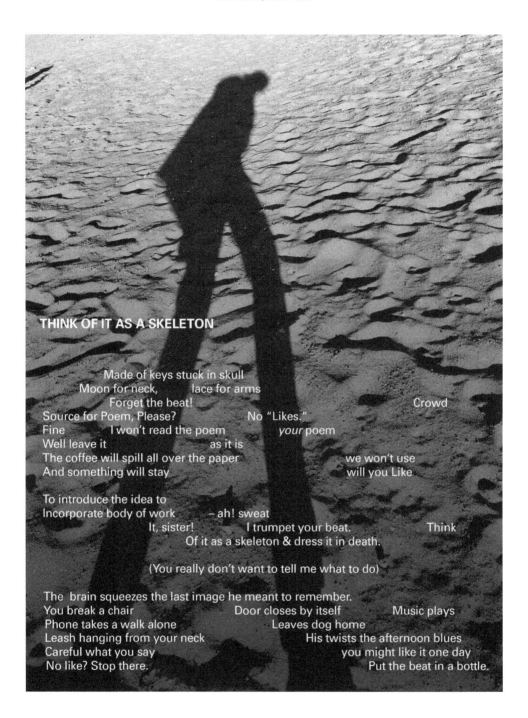

THINK OF IT AS A SKELETON

Made of keys stuck in skull
Moon for neck, lace for arms
Forget the beat! Crowd
Source for Poem, Please? No "Likes."
Fine I won't read the poem *your* poem
Well leave it as it is
The coffee will spill all over the paper we won't use
And something will stay will you Like

To introduce the idea to
Incorporate body of work – ah! sweat
 It, sister! I trumpet your beat. Think
 Of it as a skeleton & dress it in death.

(You really don't want to tell me what to do)

The brain squeezes the last image he meant to remember.
You break a chair Door closes by itself Music plays
Phone takes a walk alone Leaves dog home
Leash hanging from your neck His twists the afternoon blues
Careful what you say you might like it one day
No like? Stop there. Put the beat in a bottle.

THINK OF IT AS A SKELETON

digital image and poem

LIMELIKE

digital image

I STAND COMPLETELY NAKED BEFORE YOU

digital photo

NEELI CHERKOVSKI

SAN FRANCISCO, CALIFORNIA

I WANT TO BE A DEAD POET

(For Senol Erdogan)

I want to be a dead poet
alive beyond life
sitting at a corner table
in our neighborhood café
like Paul Verlaine
sipping absinthe on a warm
and rapturous summer's day

I want to be a dead poet
and learn how to speak the great
languages of the world
from Urdu to Bangla
a man of mountain words
and desert commas
a brick man and a birch poet

I want to sit with John Milton
dance with Emily Dickinson
grab Rimbaud on a side street in Paris
I must talk with Philip Lamantia
the Surrealist poet
and Charles Bukowski
yet another run to the liquor store
on Sunset Boulevard
where Ned smokes cheap cigars
and sells beer by the caseload

I'm tired of being an old man
my feet ache, knees weak
they are taking away my license
my poems were never published
in the Pocket Poets

rain threatens our beloved town
I will stand, arms outspread

I want to be a dead poet
walking with Homer
along Ionian shores
I'll embrace Dante in Verona

now it is 5 am
I grow frailer by the minute
yet life is good
I love breathing
every minute counts

oh to be a dead poet
beloved in eternity

last week I walked
with my partner
in the deer park
we fed rabbits and
waved to the baboons

I saw two does
eating sugar from
the hands of Gautama

next week I'll climb
the mountain
to probe sturdy junipers
where snow is like ash
purple lichen clinches
obdurate rock

i would become sainted
and wear a name-tag
at the literary convention

I want to be a dead poet
because nothing else matters

life depends on such a state

I'll count butterflies
in the world to come
eat sounds of drummers
until stones are lit
like Roman candles

I want to take one last drive
on Funsyon Beach
stroll the cliff with Orion
who carries our planet

I want to be a dead poet
and drink till my eyes spin
in a favorite dive
with Jack and Jill
far into the night

trees giggle
flowers wear party hats—
death is proud and primitive

I want to sing for cosmic rust
and ride a comet into the heart
of our lonely bed
where, propped by a pillow,
I'll be eager to sleep

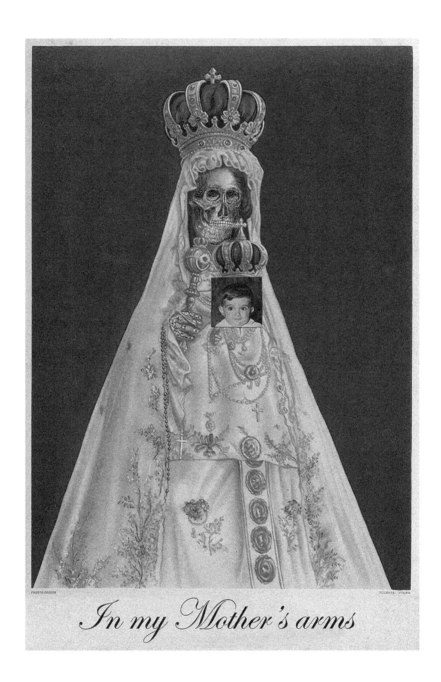

LOOP

mixed media

MICHELLE WHITTAKER

EAST SETAUKET, NEW YORK

HE IS HE IS HE IS

A Facebook post: wears my dead grandfather's face as his eyes follow bank
balling me behind the thick fame like Shostakovich's framed glasses except
he is a black man

of Panamanian roots
rim spinning in front
of a peasantry house
under a metal veranda
where I have not visited
in the long look of his quiet face like that of a watch maker delicately
nodding a salute

to mechanical flashes of flesh
as if handling rose oils and bowties. He holds a glass of cleared rum and ice
splayed above his crossed legs in a way I somewhat recall
A fake picture in me
watches him suck
an oxtail's bone until
it crumbles into an odyssey.
Who might like or dislike
me crying about this
would think I am
mourning for animal
violated of its privacy—
for I understand now
that not saying something
scatters the distance

STEVE DALACHINSKY

NEW YORK, NEW YORK

COPY SELF 2

again we are here again - memory brings us here again
 life / fiction / effacement
the anguish of the precarious / drinking coffee with the clouds
the moon covers its face in silence & shame & we are here again
stars attract stars rising turning shooting burning
falling through the atmosphere the moon covering its face
& "it's déjà vu all over again" it's better to forget than to remember
hands covering faces / covering hearts / covering genitals
the importance of secrecy / the rape of privacy
excess access access excess hands that cover the image / the imagination
so many parts of the body > heart foot fingernail enchanted soul
the voice that edits the text / hands covering mouths / covering eyes / covering ears
letters forming languages & more than languages / extremities of extremities
impregnated with memories / proportionate to history
the memory of passion / the passion of memory / of history /
the discipline of exile / the edited text / the enchanted soul
interior / exterior > the moon covering its face with silence & shame
the noise of silence / the birds of silence / the silence of silence
forget time / forget all impressions of eternity / forget memories / forget silence
forget forgetting & forfeit your rights STOP
she cover(t)s her face / she turns her head / she turns / the noise of silence / loudness
of silence / birds of silence / silence of silence
she is a copy of herself / she is memory / a copy of a copy / mesmos /
mesmos autographia / prime position / the memory of self / my self
the discipline of exile / i have copied myself so many times / the memory of copies /
desires / forgetfulness / the discipline of the exile / a copy of a copy of a copy
i am impregnated with memory proportionate to history / a history of memory &
passion that empties into silence / as i empty into silence /
ritual / food / clothing / money / dismay / action / promises / reflections / loosening
hinge / an earth man / an earth man / i am an earthman / a sin /a crime / a scissor to
cut this copy of a copy of a copy of this silence / this silence / a scissor to cut this
silence / this self / a copy of a copy / of myself / i am a copy of myself / you are a copy
of yourself / i am a copy of yourself / you are a copy of myself / we are a copy of our
self / the self / the memory of self / the process of self / she is a copy of herself /
myself / a likeness of self / a symbol / a word / a tool / a thought / a sound / a gesture /
a grunt / a groan / the structure / the text / the bones

she is a copy of me a copy of she is a copy of i am a copy of we are a copy of they are
a copy of i am a copy of i am a copy of... you are copy of... we are a copy of... they are
a copy of... all are copy of...a copy of...a copy of...

ROGER CONOVER

FREEPORT, MAINE

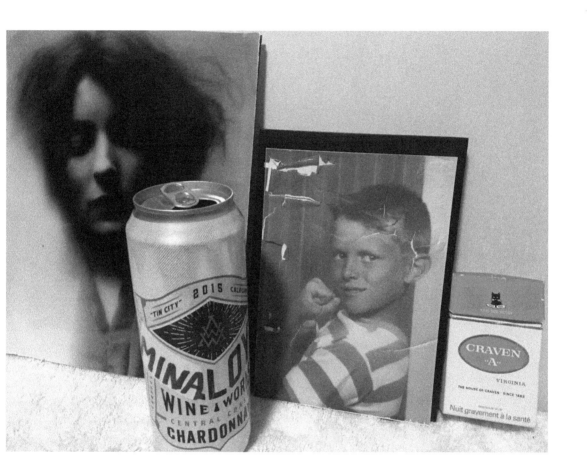

A CABINET OF CRAVANOLOYOSITIES

mixed media

FRED MARCHANT

ARLINGTON, MASSACHUSETTS

ORBISON

idegosuperego sound
 the entire shebang,
an imaginary friend,
 my worst best self,
and vice versa,
 pre-teen preoccupation,
halo in the helmet,
 dream's primary process,
the uninterrupted,
 ongoing one and only,
beyond interpretation,
 the from-which-when,
pure breath without meaning,
 of unknown origin,
how this all began,
 whether as a thorn,
in the amygdala,
 or a blowfly that settled,
wings waving,
 (though they sound
like buzzing),
 eyes with a thousand
lenses and images,
 my ointment-stuck
panicky wings, flimsies,
 weak and weaker still,
my total rackensack*
 sack-en-rack
sack-crack-den
 filled with blue sirens
and the Top 40 oldies,
 me strapped to a mast
and out on the floor
 feeling Roy watching
over me, Mercy,
 dngndndngdnndnngdnnd
and if you've heard it,
 you know what I mean

*a hardscrabble, backwoods, wilderness region, a seemingly worthless landscape not fit for civilization
—from the Arkansas State Archives

W. K. STRATTON

ROUND ROCK, TEXAS

LIGHTNIN' AT THE RODEO

I saw Lightnin' at a rodeo in 1969.
I was a scared white boy of thirteen.
Fred Whitfield, who'd become the best roper
 I ever saw swing a piggin' string,
Sat with his family in the bleachers.
He was three years old.
Fred's eyes never blinked. His hands scampered.
My dad was a small-time stock contractor,
A white man from Brenham.
Mother never consorted with the "coloreds"
 — her term, not Dad's — so she was absent.
I spied worlds in the splintery bleachers.
I saw everything good and rich Africa could produce:
Africa, where we all began.
I studied young Fred Whitfield's eyes.
Lightnin' sipped at a Pearl can
And smoked a cigar at the same time,
His own pupils hidden behind yellow-green shades.
As usual, he wore a straw Western hat.
This is a real cowboy story.
Lightnin' loved rodeo. We were at a makeshift arena
Halfway between Hockley and Prairie View
Off Kickapoo Road.
Two black women danced in golden shorts
And Western hats and boots, blouses knotted
 below their breasts,
And Lightnin' looked them over and mumbled
He'd give up a good Gibson guitar to taste that syrup.
I might have offered even more.
Lightnin' picked blues that night for cowboys
In chaps who limped from busted up legs
 while they cursed broncs that threw them.
Accompanying Lightnin' were a man with a washboard
And a man who kept rhythm by dancing
On a pallet cut from green pines that grew along
Big Brazos.
Lightnin' never gave me a glance.
He asked for more Pearl.
I helped Dad load the horses, steers, bulls,
And calves in trailers drawn by two worn-out
Peterbilt cabovers. We hit the big bridge just past
 a midnight that had no stars or moon.
River air swept over my face.

JOHN S. PAUL

BROOKLYN, NEW YORK

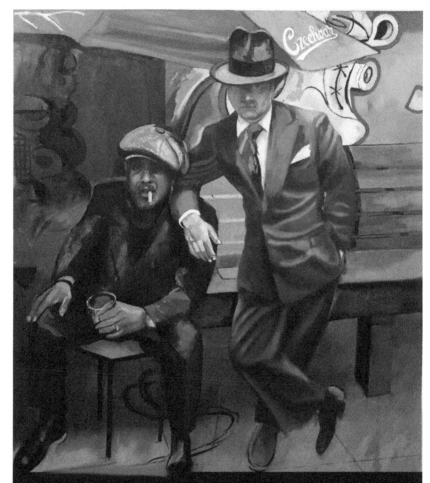

A man walks into a bar, frequently, regularly, over the courses of youth, middle age and golden . He dresses better and maintains a happy vigor.

The young ladies attending behind the bar are friendly and interesting - or seem to lead interesting lives.

He takes his first drink in hand with gratitude then asks if any of his friends are out back in the beer garden.

Too bad. Tonight there are no friends. The man is relaxing, on an easy schedule. For some time he has no secrets to cover up - a blank slate, clear deck. Nothing to lie about.

He smiles with gratitude like Edward G Robinson in one of his many honest and convincing roles- (a cashier, an insurance agent, a tailor). He gives his favorite bartender a smile and a fat tip. Maybe next time he'll see one of the boys from the old crowd. Maybe next time.

BOYZ

painting—oil on canvas—with digitally-rendered prose

LIKE, AS IF

I like people who like me.

What is the difference between a metaphor & a simile?
The word like.

Often, people use the word like when they should use
as.

I like the golden harvester in the heavens.

I like the American flag around a vanilla ice cream cone,
baseball & chocolate pie.

I like foreign films, documentaries & John Ford films.

I like the Pony Express, "Don't Fence Me In," & a train
ride over the Rockies.

I like diving into the ocean & coming up wearing a
Brooks Brothers suit.

RON KOLM

NEW YORK, NEW YORK

THE ASCENSION

I am having
A seizure—
A surfeit of liking
Has finally reached
The center of my being.

I dash down the steps
Descending in arcs
Over the carpet and out
Through the kitchen,
Blossoming
Into the night.

This likeness
Shakes my limbs
Whirling me round
The moonlit lawn
But I never touch
A single blade.

Draped in stars
I dig up the garden
Uprooting the flowers
With gestures of love.

My eyes lock
On distant vistas
And I move
Once and for all
From Earth to Heaven
In the form of a cloud.

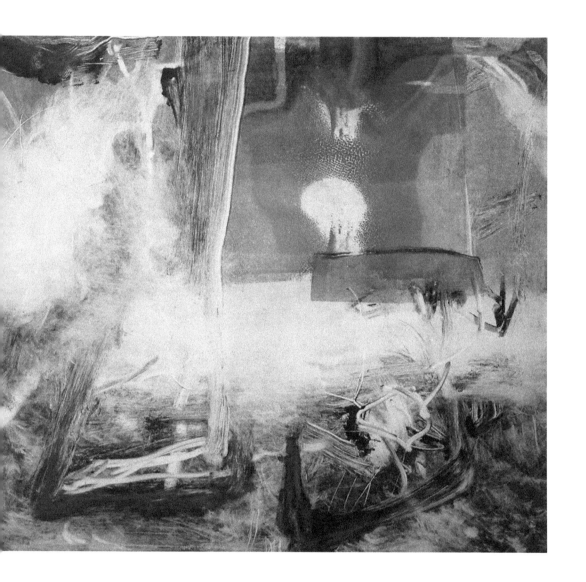

LIGHT MONOTYPE

oil on canvas

SUSAN SHUP

PARIS, FRANCE

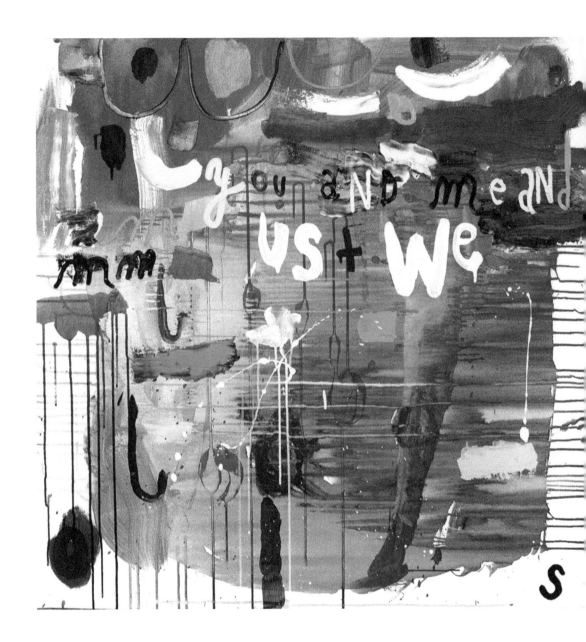

YOU AND ME AND US AND WE

mixed media on canvas, 100 x 100 cm

FRANKLIN NNANNA

ABA, NIGERIA

COAT OF MANY COLOURS

A journey we all wake up

and found ourselves into

with different colours categorized under race.

Colours don't cast, but beautify.

why not compact with different colours like the chameleon.

why stress to hate

when you can love and save yourself the stress.

Why fight for wealth

when we don't fight for air to breathe.

Why allow a disease conceived by the mind to destroy humanity,

tribal hate and religious bigotry.

Why act inhuman

when you're a human.

Why not speak language the deaf can hear and the blind can feel.

Humanity is the oldest culture

with red streams,

flowing inside every entity.

This is our world

we don't have coyote's place to go,

strive to make it a better place.

VALERY OISTEANU

NEW YORK, NEW YORK

APOCALYPTIC ILLUSIONS

Soul sucking darkness looms large in our eyes

We've lost the power of empathy, the ability to love

Maze of deceit, no one trusts anyone

Our society is a dark labyrinth of Kafka's doors

In the lobotomy alley, memory is fragile

Anesthesia is the ultimate house of youth

Amnesia looms in the afternoon of daily life

Alzheimer mania of compressed aging

Denial of all senses and human feelings

Poetry died while hidden in academic libraries

The clenching fists of rage: Art-slaves unite!

We have the secrets of uninterrupted revolution

Our hands and legs are dead dogs of war

Renouncing our sense of uselessness

Grandeur of a world morbidly rescued

From the inequality of sexes and races

From the zombies of alt-right fascism

Microwave all your cell phones

Turn off the tyrant's propaganda machine

Resist and persist to resist unfettered

While racing down the rabbit hole of illusion

There is no sunrise, only a sleepless night

Let's all meet in the paradise of psycho-magical dreams

Where we can create a world of mystical harmony.

MARK HOEFER

SAN DIEGO, CALIFORNIA

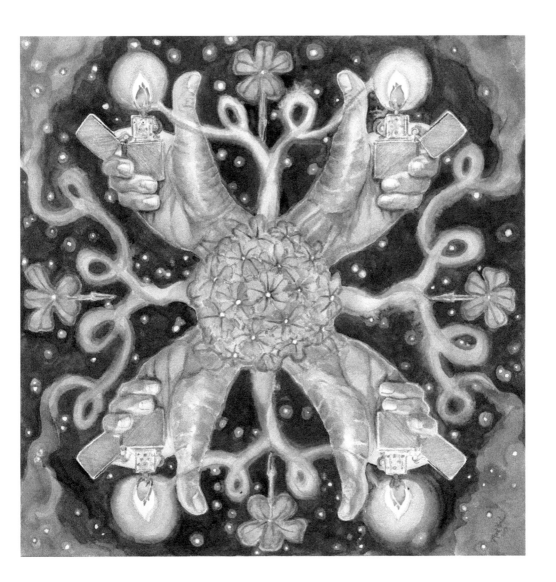

ZIPPOKAPLUMBAGO

Watercolor, 14 x 14 inches

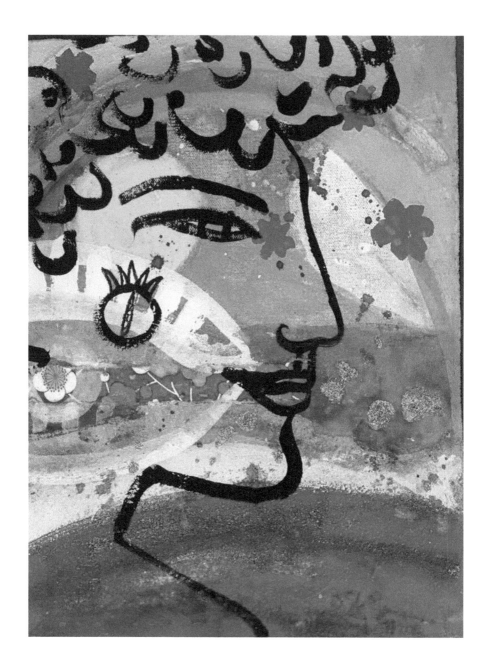

CHAVA

casein, gouache and collage on linen

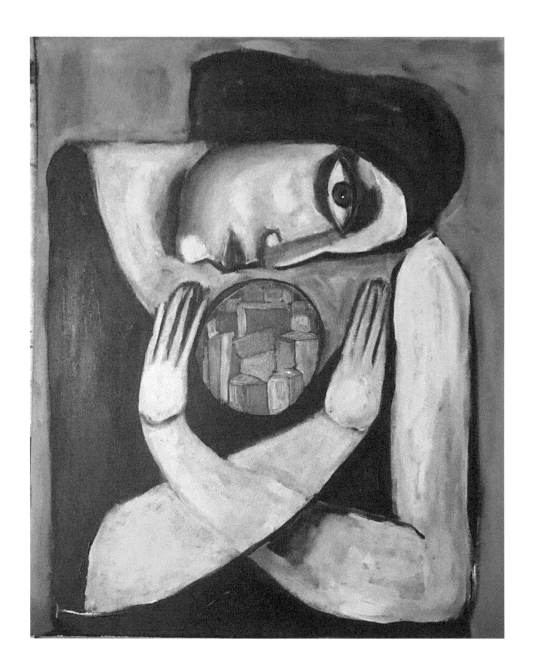

TAKING MY COUNTRY WITH ME

painting

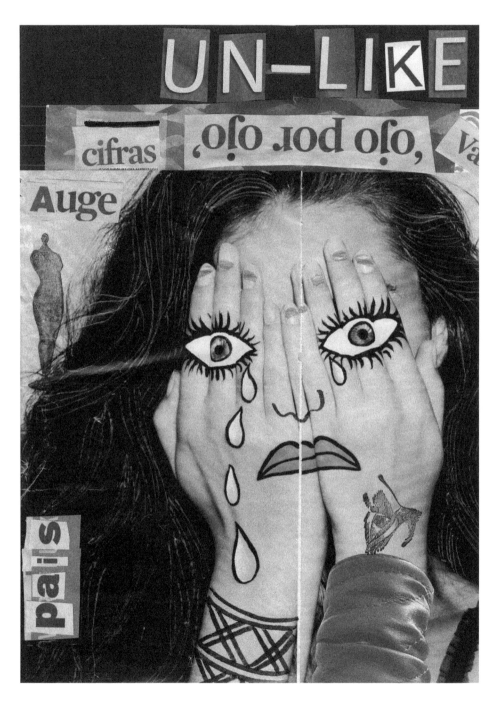

UN-LIKE

collage and illustration

BONI JOI

LUZERN, SWITZERLAND

TRY IT! YOU'LL LIKE IT!

My Gyno told me that before I like something
On social media I have to like myself.

This year that happened a few times:
The first was after I asked
What's going on with the hopes and dreams
Of New England's lobster pop?

The next, when I preformed two IKEA hacks
Channeling the spirits of living women
As I siphoned off their powers like their male counterparts.

It was a loving parody.

Finally when I liked virtual reality but
Remained very fond of actual reality injected with prophecy
In order to achieve a deeper understanding
Of why I use so many cookies.

What's really really really really real?

I realized the Internet wasn't so much about shopping
As it was about learning to shave time and hope
To connect with my spending in an earnest way.

When I'm lost in a Pinterest wormhole
Please send Feline Greenies.

I do not need mink extensions
My eyelashes are long enough

They're not unlike a wine label
With a barely readable font
That everyone likes.

IULIA MILITARU

BUCHAREST, ROMANIA

IN THE NAME OF POETRY

Quotation: "Traditional ideas about identity have been tied to the notion of authenticity that such virtual experiences actively subvert. When each player can create many characters, and participate in many games, the self is not only decentered but multiplied without limit. [...] In this view, the self is not even contained in the body, but can also be realized through relationship with technology."

A dictionary of my usage: I, me, my, mine, myself = used / *By the person speaking or writing to refer to himself or herself* / You, your, yours, yourself = used / *to refer to the person being addressed together with other people regarded in the same class* etc.

Examples. Low fat poetry:

I am a flower / You are just dirt
*Why don't you rape the flower of dirt?

I am the wolf / You are a hunter
*Why don't you kill a wolf in that hunter?

I am a dream / You are the cock
*Why don't you suck my dream from your cock?

Short story: That was a winter story. The end was a happy sad one. For all those years, for all those centuries, for all . . . I've lost you somewhere down the way. I've abandoned you in a time of no return, / My darling / You are looking for me pointlessly on the streets in a station of the metro / As my voice would come from there.

Conclusion: Silence. Then. A white noise. Then. Now. In the name of Poetry, don't write like a binary asshole!

MAHNAZ BADIHIAN

SAN FRANCISCO, CALIFORNIA

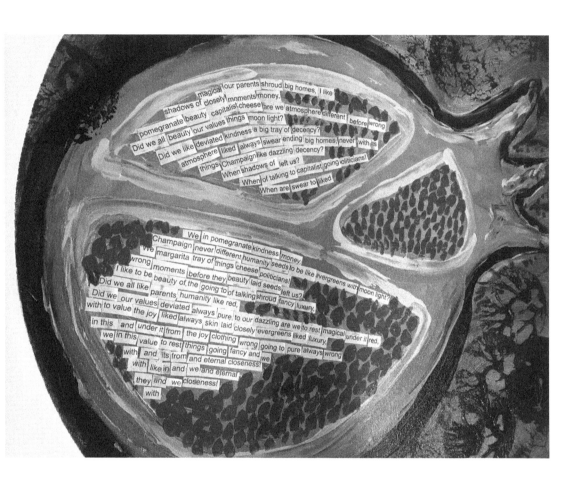

LIKE POMEGRANATE SEEDS

acrylic on canvas, 22 x 22 inches

ARE WE ALL A LIKE ? WE ALL HAVE DREAMS WE ALL HAVE

ATTRACTION, LIKING, AND LOVE

Most of us have a strong desire to **affiliate,** to develop relationships with other people, ranging from casual acquaintanceships to in-depth associations that may last a lifetime. Some of these relationships are platonic— that is, regardless of their intensity, they are based on friendship, not on physical intimacy. Other relation- ships, short-lived or lasting, emphasize sexuality and perhaps also romantic love. All these relationships begin with attraction.

LIKING

collage, A4 (21x 30 cm)

JOSHUA AMAYA

HACIENDA HEIGHTS, CALIFORNIA

EVERYBODY IS A [CELEBRITY]

you do it to yourself don't ya no? of course not, shake your head YES like you've just been approved
by a modern art museum to display your life's work *on your death bed*

ever wonder what's in the basement of the most popular museums?

hundreds of frozen heads Picassos Dalis chunks of JFK Cleopatra nude in hieroglyphs

bless your pretty little heart everybody's cheating fucking stealing. getting divorced.
remarrying. getting a second divorce. killing themselves. Leaving their will to their pet dogs.Only
difference between you and Robin Williams or fashion week or climate change
is that people aren't obsessed with the dress you decided to post on Pinterest
or the genitals you are sticking into your neighbors spouse then blogging about later
or the day you finally decide that suicide maybe isn't the best idea as you're barely saved from yourself
and that embarrassing drafted facebook suicide note
or maybe they are we all get our stomachs pumped
the me the you the them all breathe the same quality air *CHEAP ADVERTISING!*
to live = must die!
we cheat fuck steal. get divorced. remarry. get a second divorce. kill ourselves.
Leave our will to our pet dogs. and we make millions.
not money, cheese, green, dead white men we should've forgot the names of long time ago.
but mistakes. and we all love getting our picture taken
as we all die the same scheduled deaths. they've got your seven digit phone number
they'll rip you out of the yellow books all the same!

what a terrible excuse of a human being we utter to our families to our children to our parents
we use celebrity failures as examples of *who not what not how not why not where not when not*
to be
as we tuck our families our children our parents into bed
and light the whole damn house on fire.

ROBERT DUNCAN

FAIRFAX, CALIFORNIA

PAYDAY

it's the now economy,
thrumming hive of the filling of our bee-days,
frictionless, like the hype said,
rubless — not rubles — rub-less.

can't tell 1 baby on bankie from next — thumb.
your wedding — thumb
your weekend in tahoe — thumb
your cancer-dying brother
your new motorcycle
your trump sucks
you're moving to portland.

view house tongue dinner dog (binky joins the fam!)
genocide in burma.
thumb.

not a one for jim carr's cryptic tome,
between science, art and acid burnout,
about ducks on long island or composting in himalayas or —
i can hardly grasp if it is a book.
floating decimal point from high school gone full trippy.
genius, if he means it.
i hoist 1 opposable, case he does, even if he doesn't.

how else to venn with the wayward dot?
bump electro fists with the mystic?
tell him you get it, you get it — you think.
flip him a little sweetness — jimmy, on me.

JANE ORMEROD

NEW YORK, NEW YORK

SOLD OUT

This Showpiece may now be sold from the Display Strip. If you re-order or Like this Showpiece, a fresh Showpiece will be provided for commenting or affixing to the appropriate card in the Display Strip. In case of any unavoidable difference in the composition of new Stock or Posting, retain this card in your History or Stock Box and use for reference only. All sales of authenticated Showpieces revert to Packet or Profile status and any monies accrued thereupon deactivated.

SOLD OUT

digial image, 5 x 4 inches

MADO REZNIK

BUENOS ARIES, ARGENTINA

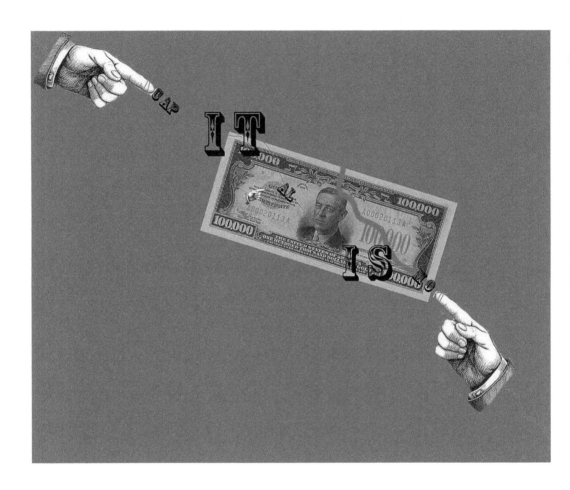

CAPITALISMO
WWW.TRICKE-DOWN ECONOMY.COM
WORDL LOW INTENSITY ACTION
(VISUAL POEM)

digital collage, 6.693 x 5.393 inches

KAREN HILDEBRAND

BROOKLYN, NEW YORK

CASH HAS NO CURRENCY

Make me, spend me, count me,
crumple me into your pockets. Sew me
into your hat and mattress. Sugar me,
daddy. I multiply so fast you get the
zeroes wrong. Squeeze me, curl me,
fry me in quail eggs. Suffer me red.
Weather the palm fronds' whip and
hew. Paper thin and snarling, hold me
up to piss and flap.

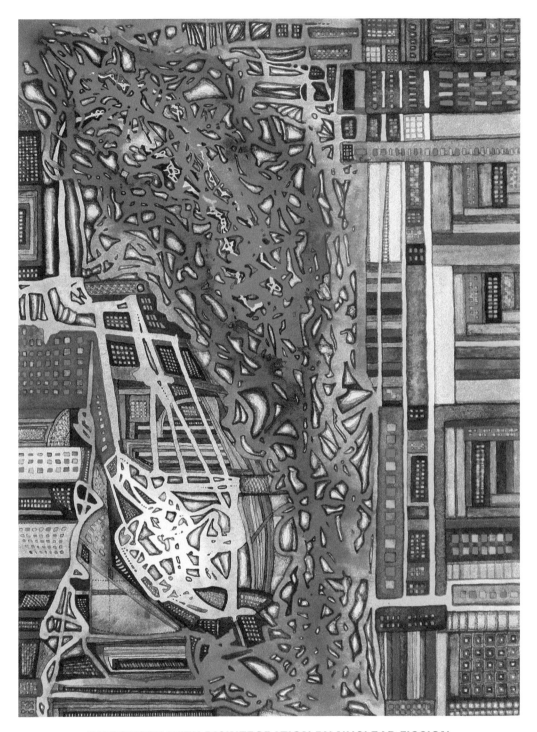

**IMPROMPTU WITH DISINTEGRATION BY NUCLEAR FISSION
(SAINT ANTHONY VERSION)**

watercolor on Fabriano paper, 28.5 x 21 cm

rockaBILLY whole world gone CANCELed
zigzagging patterns agitated displacements
considerable skills employed by some throwaway
gag trace affirmative on behalf of all
water fleas im wishing you a happy fault in the
optical superstructure woke up this morning so
bad i pollinated one of my verses mistaking it for a
real poem have to visit 3 country fairs & a goat
fucking just to come to the captains attention please
send dronized ball cutter on my behalf should i be
needed upon decomposition row no see 'em
central they have a knack of thinking big do not
cancel the sasars sky farmer upon the stirrups turbo
twat cleaning a trumpet my husband a
watercolor so tangle assholes with some
wandering star who has a good voice to
beg bacon & utters billy-no-stars does not
belong to greater london bar the
door katy is a small
difference a way out?

rockaBILLY whole world gone CANCELed

collage, 4.7 x 6.2 inches

BILL ROBERTS

NORTH SALEM, NEW YORK

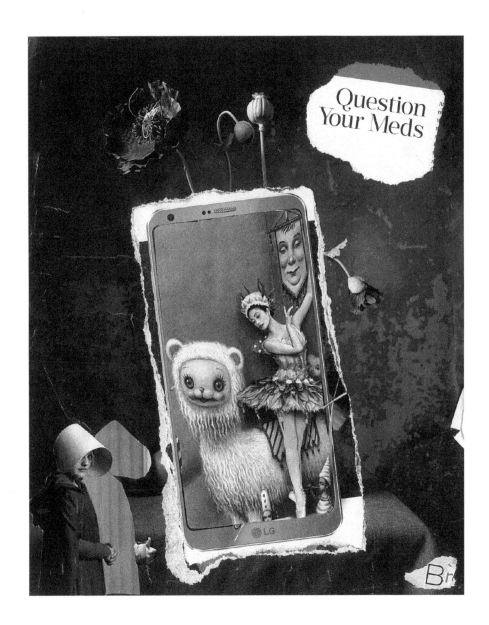

FOUR WINDS MENTAL HOSPITAL #1

collage, 8 x 10 inches

S. A. GRIFFIN

LOS ANGELES, CALIFORNIA

JESUS PIZZA SAVES

your chest is a game show with 100 nipples
your thighs are a temple of questions
I will never answer

my armpits are an odd symphony
that mumble lunar rhapsody

amorous beavers covet your wooden shoes
and would like to see you walking barefoot
in the glass factory

death is a skateboard without surprise

the president is masturbating in front of the public library
and I hate to be the bearer of fake news
but all the pages of history have been glued shut
and the law books are pleading the fifth

America, waving behind your striped and starry mask
you cannot erase memory

I cannot recall the perfect body of your mind
or the perfect wisdom of your heart
and there's something heartbreaking about a harmonica
doing blue somersaults in your ear

electric sheep litigate the future with artificial intelligence
using smart phones on speed dial

I can hear the icebergs melting in your drink

last call, lover

what's your
poison?

AIMEE HERMAN

BROOKLYN, NEW YORK

DEAR JACKSON POLLACK:
THAT DRIP IN THE FAR RIGHT CORNER WAS FOR ME

At the Museum of Modern Art on a Tuesday somewhere between lunchtime and another hurricane, I stood in front of your black-and-white binges of marathon drips and tried to read each painted scratch like an alphabet. Tried to breathe in the fumes of your whiskey pouring out of cigarette clenched between teeth ashes dried into each slash of paint. And then the person beside me clasping cell phone between hands like a weapon as though it will save us both says to me, "You like?" as though your morse code can be reduced to a thumbs up and all I could say was, "You are staring at a collection of calendars." And then the person snapped a photo of your blotches, some raised like that scar on my right forearm from that time Geoffrey B. told me he didn't like me like I liked him and I couldn't bear another human not understanding how to love me, so I dug razorblade sharpened like your paintbrush like your taste for rye and watched my own colors drip out as though I were a painting hung somewhere between New Jersey and that alleyway where my third girlfriend fingered me. For a moment I wondered how many LIKES the photo might receive, knowing we no longer photograph for us anymore we no longer eat just for us anymore we only know how to exist with an audience hidden inside screens. And before I walked away from your encrypted acrylic, I turned to the person beside me and said, "Paintings are books but they can't be read until you open them, digesting last word to first, bottom to top, count every fiber and cat hair collected in each syllable." The person just stared at me as though I were Autumn Rhythm, looked at their phone as though it could translate and said, "Already fourteen LIKES and I just got here."

Dear Jackson Pollack, what does it mean to stain the world with the pigment of question marks—WAIT—don't tell me, I like it better when I just don't know.

JOHN M. BENNETT

COLUMBUS, OHIO

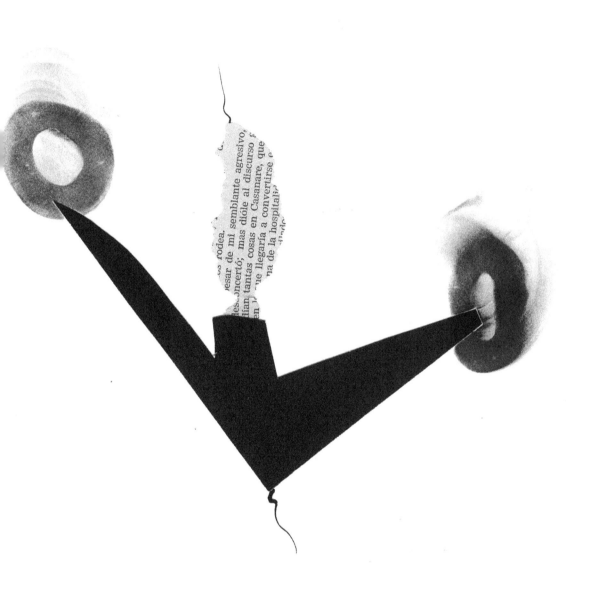

SEMBLANTE

mixed media, 8-1/2 x 11 inches

KSENIJA KOVAČEVIĆ

KRAGUJEVAC, SERBIA

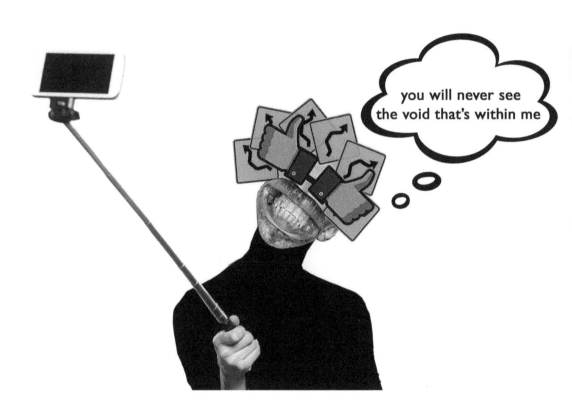

SPECTACULAR SOCIETY SPECTACLES

digital collage, 3672 x 2492 pixels

SUSAN "SHOSHANNAH" ADLER

CHAPEL HILL, NORTH CAROLINA

COGENT II

I thought we could adapt to a world of bright people

dashing around playing with ideas

We've always been so lucid

conjecturing whether a green carpet can pretend to be grass

So which is it

arbitrary or intuitive

We opened up to Gods

but Gods do not swallow words

or hear a detonating sound of discontent

There are so many misconceptions when you follow

I've spoken to a muse

but my thoughts always lead me to a beginning

I've tried to end

It is a national epidemic like a cup of joe

We are an intelligent species

malleable enough

Visit any museum and see how malleable we are

sculpted in unclothed entwining clutches

Even our secrets are thought of as great works of art

revealed in flesh that does not fade

Maybe it is a fait accompli

But bright people would say that

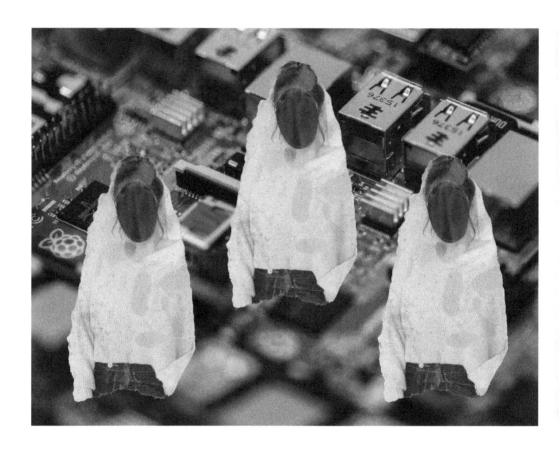

THREE WOMEN WITH BLACKED OUT FACES

digital art, variable size

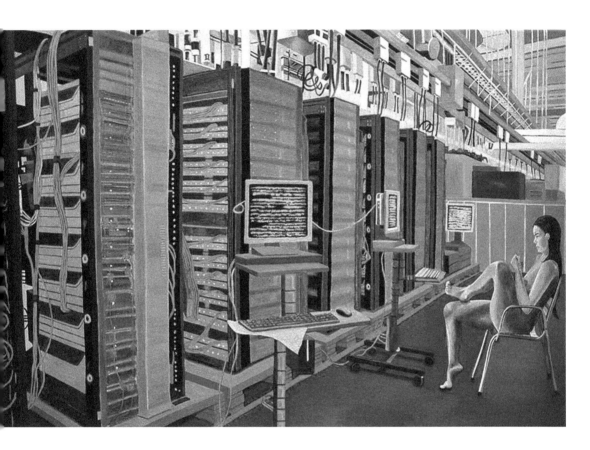

CORE SWITCH

oil on canvas

MARTINA SALISBURY

BROOKLYN, NEW YORK

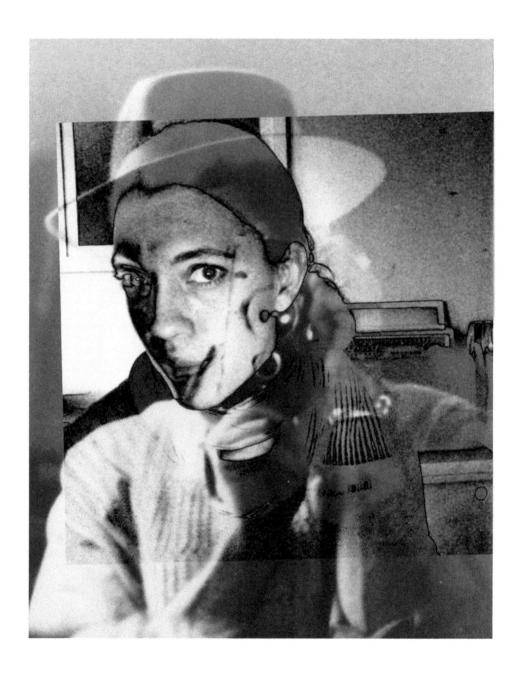

DADA SELFIE / PROFILE PHOTO: 1946 / 2011

digital collage, 4 x 5 inches (300 dpi)

DAVID LAWTON

NEW YORK, NEW YORK

10 PAST 10

They exhumed Dali's mustache
Perfectly intact at 10 past 10
Synchronize your limpid puddle of pocket watch
To confirm the persistence of surreal facial hair

The rest of him changed to a chest of drawers
It was petrifying, the decorative scrollwork
That lay beneath his magnificent handkerchief
Of knotty pine boogers

Lumberjacks extracting genetic material with a buzzsaw
Which proved that a litigious fortune teller
Who foresaw tabloid payoff through woodgrain comparison
Was nothing more than a hope chest left at the alter

For genius is an old growth forest
Count the nose hairs to total the centuries
The legend of the mustache endures
Branches spreading out at 10 past 10

KELLYE GRAY

PARIS, FRANCE

I used to like self portraits
I used to like

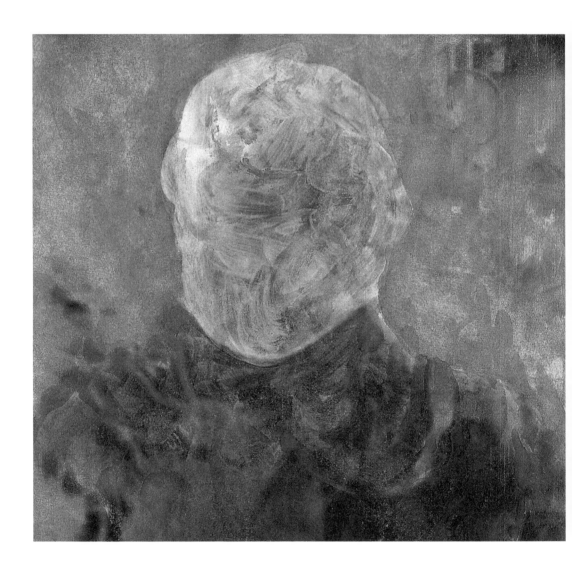

**"THE KILLERS OFTEN ASK THE NAME OF THEIR VICTIM
BEFORE THEY STRIKE" (SUDHIR KAKAR)**

tempera on paper, 145 x 135 mm

DEBORAH SIBBALD

LONDON, UNITED KINGDOM

THE TRENCHES OF TODAY

the number of families placed illegally
in bed and breakfast hotels and other
unsuitable temporary accommodation
has risen
by three hundred percent since twenty
fourteen
 rents are unaffordable
there
is a visible rise
in the numbers
 of multi million
housing developments and the
constructors must guarantee to
include a number of
affordable homes
though rich investors don't want
to mix
 with less well off tenants
so build seperate entrances
bicycle sheds and bin sheds where
people sleep hidden
from closed circuit television
 nineteen thousand empty buildings
 are units for investors
accumulating wealth

three thousand and sixty nine people
are seen sleeping rough on any night
in public places under dripping
bridges
beneath umbrellas or tents in parks
subways
and doorways
 are you in priority need
or intentionally homeless
 priced out
The average age of death
of someone sleeping rough is
 Forty nine

ROBERT PETRICK

NEW YORK, NEW YORK

DADA

DADA LIKE

digital, 12 x 15 inches

KATHERINE SLOAN

WOODSIDE, NEW YORK

WHAT IS "DADA"?

What is it like?

Dada is or Dada isn't.

Man Ray wrote on July 8th, 1958: "Why? Who cares? Who doesn't care? Dada is dead. Or is Dada still alive? We cannot revive something that is alive just as we cannot revive anything that is dead. Is Dadadead? Is Dadalive? Dada is. Dadaism."

To me, when we're alone together, in bed, with a slight high (generated from our bodies, our pheromones, our both being born in the year of the dragon), laughing, making love, having moments—spasms—of happiness and joy, that's Dada at its most alive. I remember saying "I feel as if I'm in a trance." That was the moment. That was Dada: it didn't make sense. It wasn't logical. It wasn't planned. It went against what we're supposed to do in a society at war with itself.

In this case, Dada isn't an "ism" as much as an "asm" (as in chasm, spasm, and orgasm).

Q and A:

Man Ray: Why? Who cares?

Me: Because I care. Because I like it.

MR: Who doesn't care?

Me: Dada is the act of not caring and not over-analyzing matters. It doesn't matter if it is likeable or not. This makes Dadalive. Dada lives.

TRISTAN TZARA
LUCA VALLINO & ANNA O'MEARA, TRANSLATORS
LA JOLLA, CALIFORNIA & HUDSON, NEW YORK

RAISON D'ÊTRE

sur nos têtes un seul oiseau

dans nos mains la main volante

c'est la même c'est le temps

un seul vent brûle nos épaules

et sous des voyelles amères

la mémoire sans audace

l'eau vive que nous fûmes

à la naissance des paroles

nous avions plié les routes

les ciseaux se sont mis en marche

au bruit des découvertes futures

les jardins figés dans la pénombre de nos
 bouches

coeur trouvé la flûte pleine

enfant des flammes sans fumée

limpide première

il y a du soleil dans les doigts aveugles

qui comptent les marchés de la ville

dans nos têtes à provisions

par la criaillerie des marées

parmi les fruits et les batailles

allumez les mots d'étoiles

qui perde gagne

l'immobile raison de l'eau

RAISON D'ÊTRE

over our heads a single bird

in our hands the hand-crank

it's the same thing it's time

one sole wind scalds our shoulders

and under bitter vowels

disemboldened memory

the running water that we were

at the birth of our poetics

we had curved the roads

the scissors start their own advance

to the beat of future discoveries

the gardens petrified in the twilight of our
 mouths

heart found full-fluted

child of the smokeless flames

transparent novice

there is sunlight in the blind fingers

that tally the village markets

in our grocery heads

through the shrieking of the tide

among its fruit and battles

ignite words with stars

he who loses wins

the inert reason of the waters

JAAN MALIN

TARTU, ESTONIA

ALL

WE ALL ARE A "LIKE"

WE ALL ARE A "BIKE"

WE ALL ARE A "HIKE"

ALLA HEAR WIELE

ALLA WEAR KIEBE

ALLA HEIL KEWERA

KAREL LAWALE "EI"

KAREL WAIBE "ELA"

HELLER BEE KIWA

KAWE ALL ARE LIE

KAWE ALL ARE BIE

KAWE ALL ARE HIE

SO NUBER DUHER

RONBU HERE ISUD

BINHO UDER SEUR

SWITCH IT ON FRIEND

ON IT FRIEND SWITCH

IT SWITCH FRIEND ON

FRIEND SWITCH me ON

for mesampy Finland

Hong-Kong cheeze

vink vonk phraize

King Kong creaze

ping pong praize

ling long laize

DA DA DA

DADADA

da da da

dadada

da da

dada

da

da

da

JOEL ALLEGRETTI

FORT LEE, NEW JERSEY

POEM IN 140 CHARACTERS

LABYRINTHITESIS

digital print, 20 x 20 inches

JÖRG PIRINGER

VIENNA, AUSTRIA

left

LEFT

digital visual poetry

MAW SHEIN WIN

EL CERRITO, CALIFORNIA

HYENA

the iris is the bone

of the eye

what i do is blink

four times in the

face of a tornado

and like you

your profile

your cover the hyena cackles

spine twists

into a question mark

my flesh swung

around a bone

it's strange

how the cause

is the cure

is the cause

COMMUNION BY ALEXANDER MELAMID

role game documented by studio photography, 120 x 180 inches

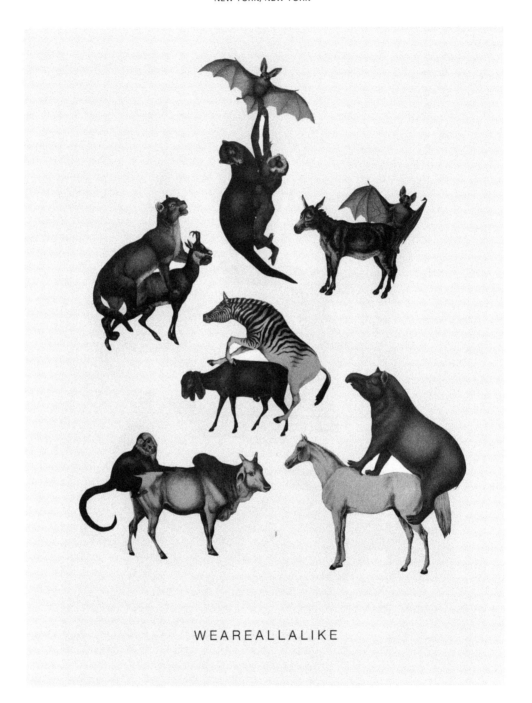

WEAREALLALIKE

WEAREALLALIKE

collage on gessoed paper, 30 x 20 inches

SAM DODSON

RAMSGATE, UNITED KINGDOM

THE TRANSHUMANIST TRANSGENDER TRANSRACE TRANSBELIEF TRANSMITTER

manual collage on canvas, 153 x 40 cm

NEAL SKOOTER TAYLOR

LOS ANGELES, CALIFORNIA

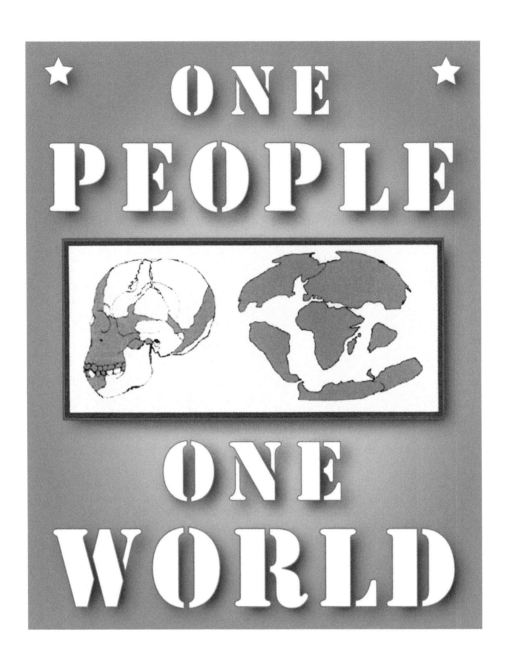

ONE PEOPLE – ONE WORLD

any media – any size

LINDA J. ALBERTANO

VENICE, CALIFORNIA

I "LIKE" YOUR DOPPELGANGER!

Some say that Hitler's doubles were all a like. At least the one they found in the bunker with Eva Braun.

Some say he fooled the Russian army for 3 whole days. But, NO . . . despite his lopsided hairdo and absurdly parsimonious upper lip décor.

Some say he was too damned short to be the absolute McCoy. Plus . . . suicide with a bullet planted precisely between those eyebrows? With zero powder burns to show for it?? Exactly.

Some say their devious escapee had simply hopped a willing submarine and chunneled under the Atlantic (disgorging in Buenos Aires).

Would that other odious despots should but stow away on errant U-boats and live their last irrelevant decades as addled gauchos bellowing self-praise to startled longhorns on the Argentine Pampas!

One eternal day, they . . . and we . . . will be as fine silt drifting between Indianapolis and the rings of Saturn.

In that singular spit of time we shall all, quite bravely and equitably, be nothing . . . but persistently, unavoidably, inexorably, undeniably, irrevocably and utterly

a like.

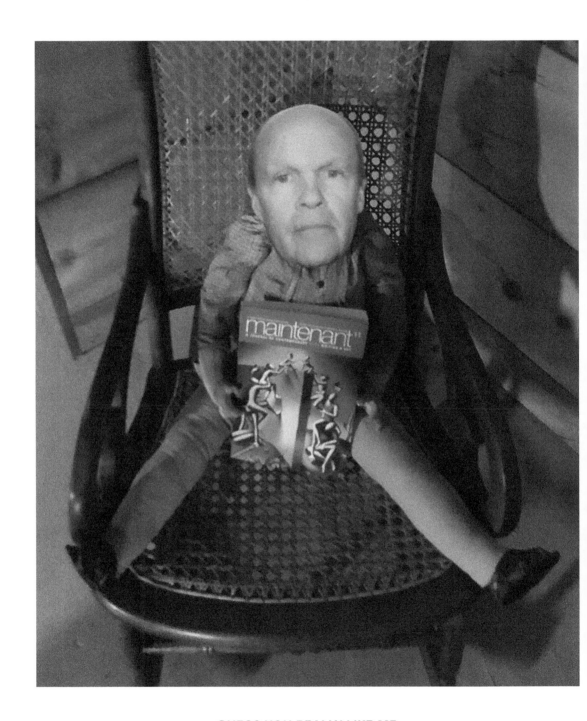

GUESS YOU REALLY LIKE ME

digital collage

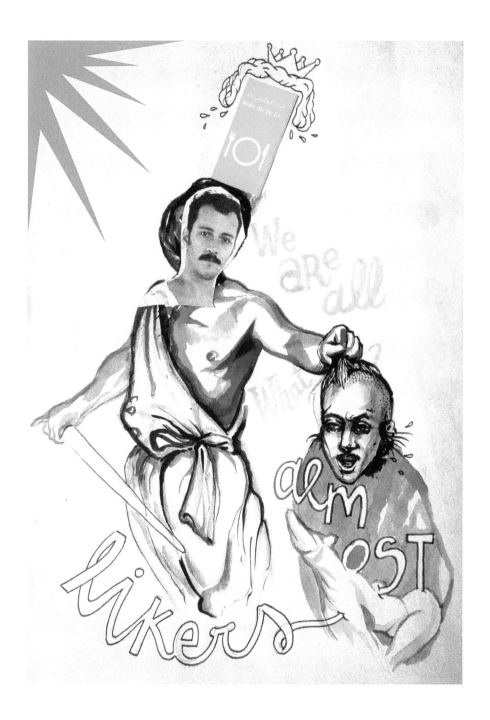

LIKERS

collage / illustration

ANGELA CAPORASO

CASERTA, ITALY

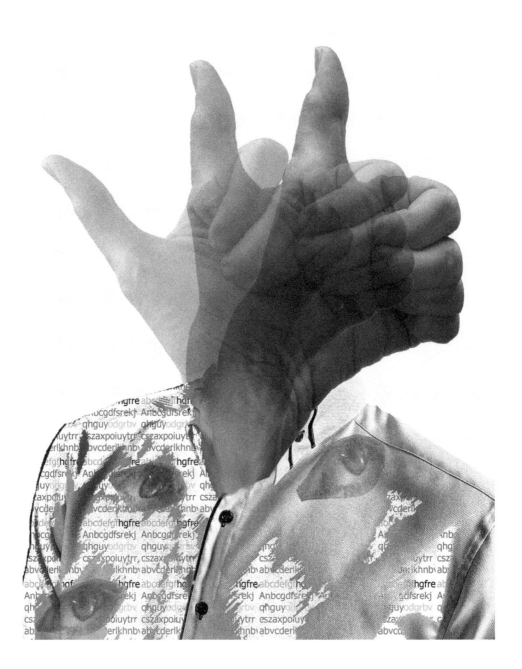

UNO DUE TRE

digital collage

DEAR FRIEND

Dear Friend:

Thank you for "liking" my recent Facebook post about unraveling the tangled strands of personal integrity.

In the interest of strengthening our friendship, please respond to this survey so that I may better understand our common and complementary points of view. Please mark all relevant responses.

What impressed you most about the aforementioned comment:
[] a. Its accuracy; [] b. Its brevity; [] c. My use of language; [] d. My original perspective

Which of these topics, if any, are likely to engage your attention:
[] a. Politics; [] b. Celebrity gossip; [] c. Philosophical musings; [] d. Ribald jokes

Which of these circumstances will increase the chance that you will "like" a future comment:
[] a. Impeccable logic; [] b. The liberal use of capital letters or exclamation marks;
[] c. Sarcasm; [] d. The fact that the comment was liked by mutual friends;

On a scale (from low to high) of 1 – 5, rate the following topics as likely to elicit a "like"?
[] a. The Pros and Cons of Nuance; [] b. Faith-based Atheism; [] c. Freedom's Prey;
[] d. Plumbing Ambiguity; [] e. The Impending and Overdue Reemergence of Cursive

As always, it is my objective, and my pleasure, to provide the best in friendship experiences.

Zev

ALEXANDER LIMAREV
NOVOSIBIRSK, RUSSIA

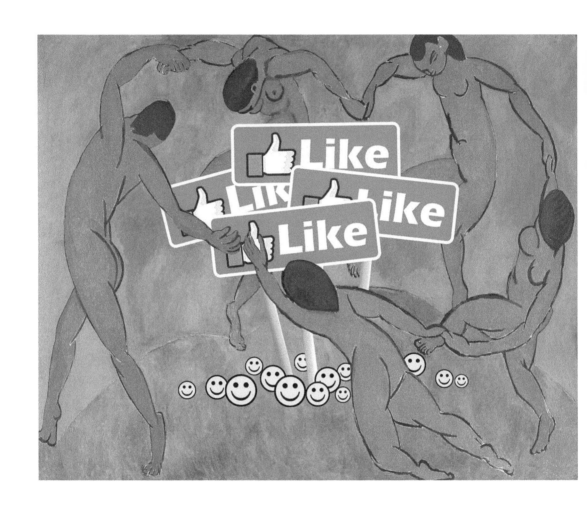

EKIL A LLA ERA EW

digital collage, 4 x 5 inches

I LIKE YOU LIKE YOU: A CONVERSATION

Do you like Tony?

I like him okay.

I mean do you like him like him?

I don't LIKE him like him. I like him as a friend.

How come you don't like him like him?

I don't know. I just like him like I like him.

I think he likes you, though.

Maybe, but I like someone else.

WHO?

I'd rather not say.

Come on. I won't say anything.

OK, but you better not. (Whispers name.)

You can't like him. He likes Melissa.

He likes her likes her?

Yeah, she told me he told her he likes her likes her.

Aw, man.

You should just like Tony.

I guess I could like him.

You may as well.

Yeah. He's okay.

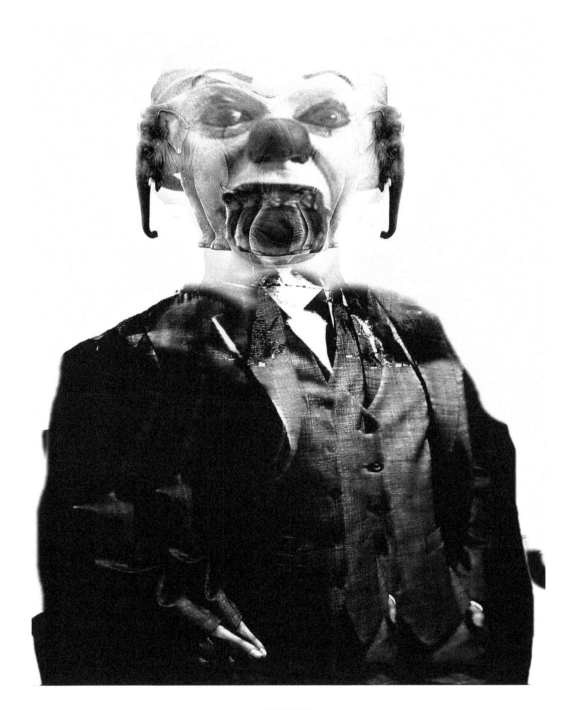

MISTER

digital mixed media, 50 x 50 cm

CHRISTIAN GEORGESCU

SUNNYSIDE, NEW YORK

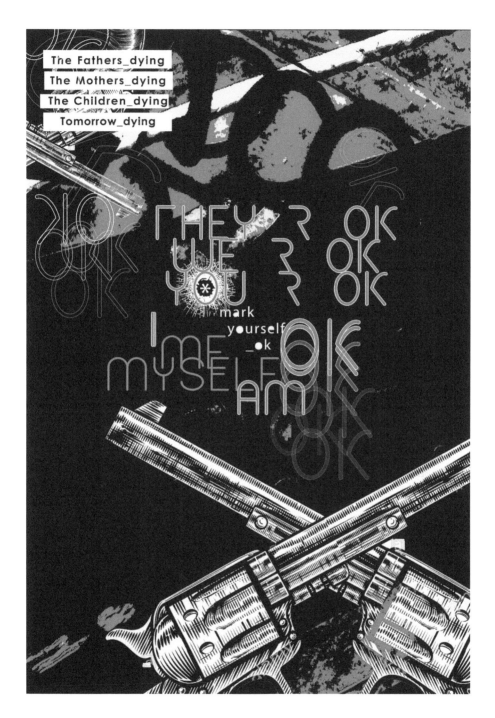

LINEAR DODGE

digital collage, 2099 x 3042 pixels

SCOTT WANNBERG

1953–2011

the war is pregnant

the war's really showing these days.

not sure whether it's a boy or girl.

the war passed out in a maternity shop yesterday morning.

blame it on the heat.

the heat is getting sick of always taking the blame.

the heat has hired a supposedly competent attorney.

the war demands pickled pig's feet.

nothing open this late.

the war paces up and down the living room.

i saw barack obama and john mccain fighting over a surfboard.

maybe it meant something once

but the waves disappeared,

how can you ride a catatonic sea?

will the war undergo a caesarian?

i want to have a hundred children, the war smiled.

once there was this movie,

everyone in it did okay.

maybe it was science fiction,

the actors got younger with every passing second.

you'll need to find an eclectic video store

to nab this sucker.

we go around in circles.

we want to do well.

the war would like to eat us.

dumb ass.

i was not born digestible.

W. A. DAVISON

TORONTO, CANADA

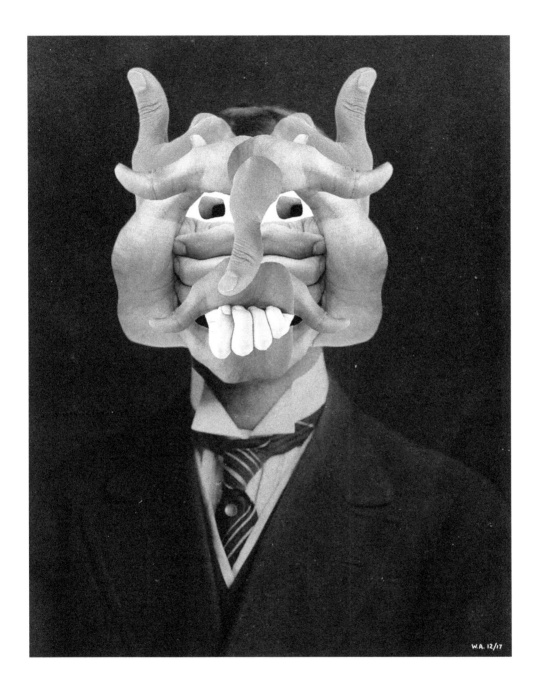

ALL THUMBS

digital collage, 1200 x 1500 pixels

PAWEL PETASZ

ELBLAG, POLAND

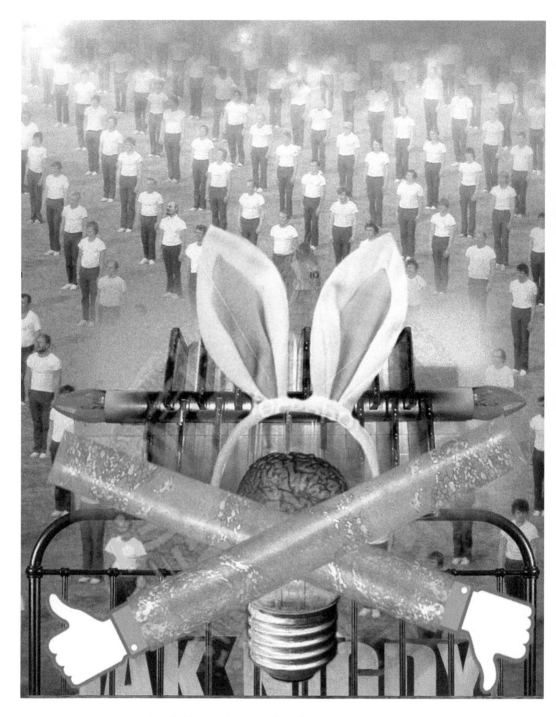

DEMOCRACY VS. ARTIFICAL INTELEGENCE

digital collage

JOANIE H. F. ZOSIKE

NEW YORK, NEW YORK

Juche Year 106
December 4, 2017

According to Wikipedia), the Juche calendar begins with the birth of the leader, Kim Il-sung, His 1912 birth anniversary was decreed "the Day of the Sun." The Juche calendar was adopted on 9 September 1997, the Day of the Foundation of the Republic. 1912 represents "Juche 1" in this calendar. Thus, "Gregorian 2017" is "Juche 106."

Adieu, A.D., you have been unliked
A calendar is history. Light the match
One senile lunatic and a bratty maniac tussle
on a king-sized bed of peanut-cock feathers
Orange is besmirched. Fake newsie spittle
conspicuously slides over Kim's print font
Daggers pierce the flesh of failing giants

Vows of devotion reap gooey reverence
Lying pussy-grabbers have privileged liberty
to outstretch their tiny hands and grasp with
impuny-ty. If you eat the best, you are the best
An erectile majesty fakes his turkey pardon; rather,
he carves fellatial estates into quaking monuments
It's gonna be fantastic, the best,

Dress in sharkskin so that ye will know me
Observe as I cleave countryside and bumpkin
with the same diamond machetes the ancestors
of empires used. It is an undressed horror
a thing of perfect beauty we watch, cringing
Ten-hut, your goose-steps are showing

Dotage, an old bastard, wipes baby tyrant's nose
The issue of this intercourse spawns cream of the
crap. Year of the sour pinnacle of racist backlash
Cunts, kikes and niggers (same thing) will never
gain entrance to your mucous-colored golf links

A shivering nation views your Teutonic tweeted
Capitalizations: American Kristallnachts, tardy
Juneteenths; your maneuvers do not go unobserved
Achtung! Attention must be paid, seriously paid off

The atmosphere is indigenous, vertiginous, covered
In white sheets. Mylar, careless glittery GOD
Thy overstated stultifying sputum pervades engrams
And all the whitewashed girls sing:
Tweet-da-tweet tweet-dippdy-dip tweet— ah-ooh

Come to a screeching HALT. Peer into the word cloud
Through a smokescreen of lousy visibility, behold a
Panorama of jingo-besotted generals and pawns who
benefit from blind resolve. They raise their legs up high
Rockettes. Place giblets in huge slingshots; aim surgically
Look out! Look out, Chicken Little! The country is falling

JOCHE YEAR 106

text and emojis

JEFF FARR & LAURIE STEELINK

NEW YORK, NEW YORK & SAN PEDRO, CALIFORNIA

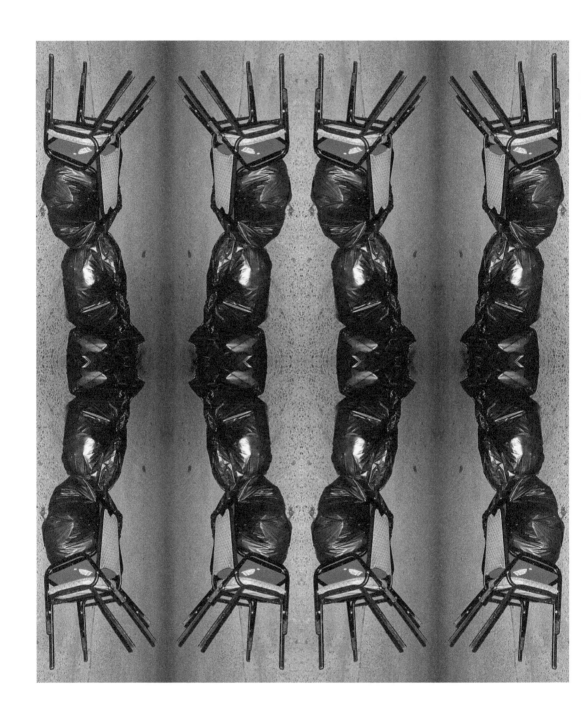

IT'S NOT WHAT HAPPENS IT'S HOW YOU HANDLE IT

digital collage

MIKE M. MOLLETT

LOS ANGELES, CALIFORNIA

(=:)>-+$@%=☺(xo)*?&^!!~ (with & w/out prophylaxis)

Yikes *a Like*! **Not** another one!
Those damned things! Trip over them!
They're everywhere I look- Likes. Loves, thumbs-up, thumbs-down
**on ABC, CNN, @ the mall on the clothing floors (all floors), w/ the
demonstrators, their friends & un-friends, soc media, credit cards,
bitcoins...in my breakfast cereal & the ballot box, in the front of
another line, the whole line @ the surgeons, the burger joint, the 5 star
hotel, in the Oval Office... You name it! LIKE WHERE ARE** THEY
COMING FROM? THEY'RE TAKING OVER OUR PLANET!
LOOK! ANOTHER ONE! **SHIT!**
THEY'RE IN MY FACE...these powerful tiny subversives!
Like insects! CAN'T GET AWAY FROM *THEM...*
shape-shifting. trans-cultural, multi-sexual entities!

THEY'RE PILED ON ☺TOP OF EACH OTHER! Almost numberless.

Sucking. Teasing. Clicking! MULTIPLYING FAST! COMING FROM
ALL DIRECTIONS!
Like crazy! ... ☺...☺

Self-Replicating emoji-like **what the☺ fuck**...Can't stop!

It's a virus+&+@+%+$+•+$+... Hello? ++

Are we ☺☺talking shit here? What time is ☺it? Baa...

baa... *I am not alone!*@#!!How'd we get involved in this

crazy this vocabulary this ☺$(_) this **Consciousness of** Like

☺ Hey? $@ +=_..:x:=:)☺>?(** ^^%$# @!

!~ What's your @&=☺ Are you a ^+☺vegan? ☺

(=:)>¬¬-+$@%= (XO)*?&^!!~

text with symbols

HENRIK AESHNA

PARIS, FRANCE

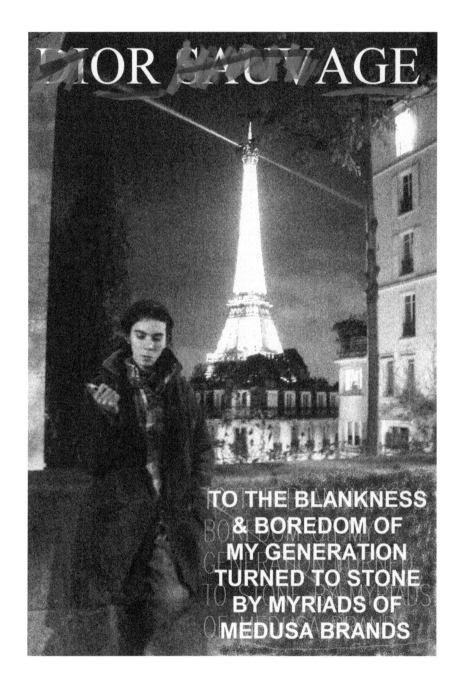

ORAGE
to the blankness & boredom of my generation turned to stone by
myriads of medusa brands (SchizoPop Manifesto)

digital collage

BIBBE HANSEN

HUDSON, NEW YORK

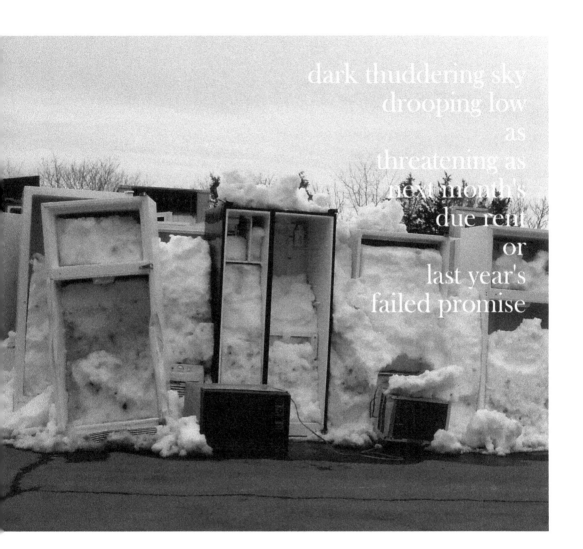

dark thuddering sky
drooping low
as
threatening as
next month's
due rent
or
last year's
failed promise

DARK THUDDERING SKY

digital photo and poem

DOBRICA KAMPERELIĆ

BELGRADE, SERBIA

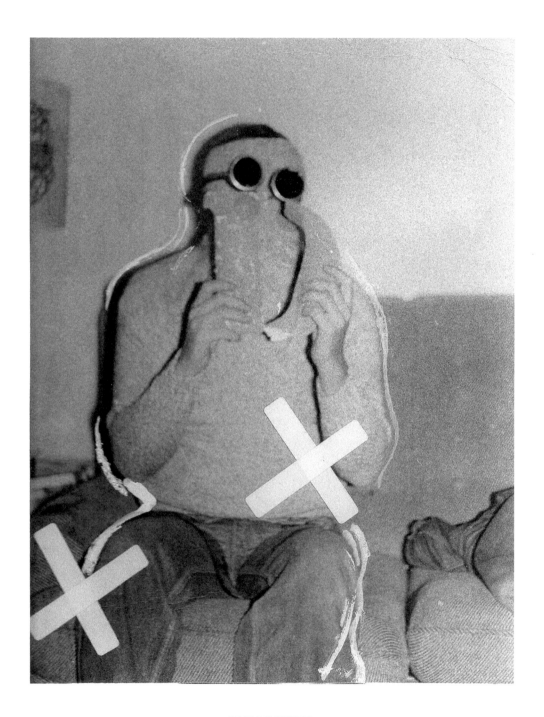

GUESS WHO?

digital collage

BIG GULP

digital photograph

AMY BASSIN & MARK BLICKLEY

LONG ISLAND CITY, NEW YORK

Testosterone Poisoning

My Daddy taught me that when a man expends his precious bodily fluid, it upsets his internal chemistry and drains him of a large portion of his intellectual and creative energies.

A women's sole purpose on this earth is to zap up a man's vitality by having him transfer it into her. It's artistic destruction by injection, if you know what I mean.

TESTOSTERONE POISONING

text-based archival digital print, 16 x 20 inches

HARALDUR ÁGÚSTSSON

LONDON, UNITED KINGDOM

LOVE AFFAIR

digital image, 1024 x 585 pixels

LABOR ENDS WHEN DADA IS BORN

digital photograph, 5 x 7 inches

CLAUDE PÉLIEU

1934 – 2002

SILENT CRIES, HYSTERICAL MIKES.

In an ultra-violet room, unwinding a string, a compensation of string, a woman lies down on the Journal of Pity — it was a likeness.

An argument mirror justifying not reflecting — Skylights, pathetic cabins, the recoil of eyes affirms that the answers of the computer are rigged — contrary to each concept apparitions spread, & that woman I saw dead (I can say that I lowered my eyes) — fell like a torch, underlining the horror.

The intense daily routine.

The shadow of a regret on that body mutilated by work & pleasure. (I imagine that body intact), but through that play of mirrors the body cries out "Old Age!" & order is retained.

If sexual repression exists it's because men always speak of their organs through the window of conceit.

from Jukeboxes (les micros hystériques) poèmes 1967-1970,
Claude Pélieu, 10/18

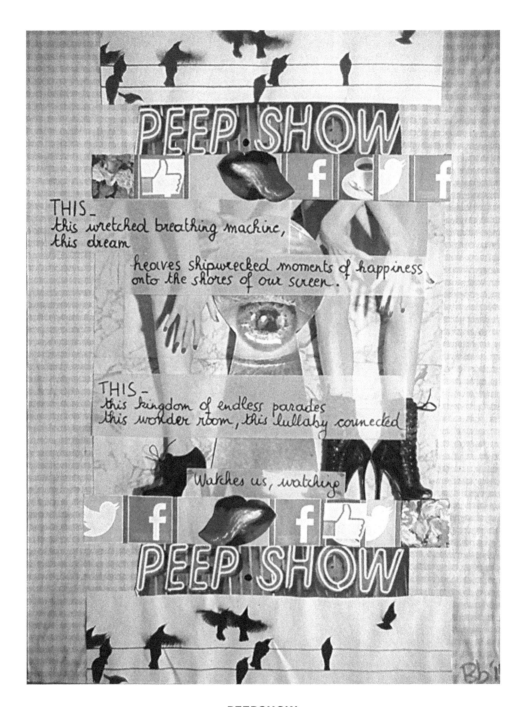

PEEPSHOW

collage, 27 x 36 cm

POUL R. WEILE

BERLIN, GERMANY

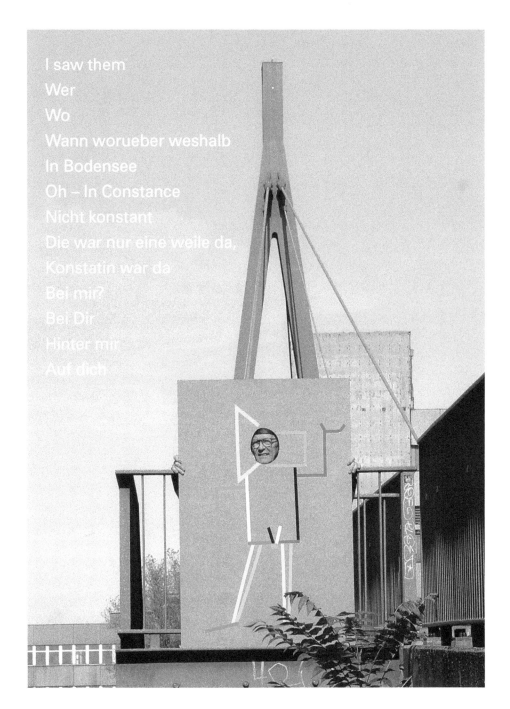

I saw them
Wer
Wo
Wann worueber weshalb
In Bodensee
Oh – In Constance
Nicht konstant
Die war nur eine weile da,
Konstatin war da
Bei mir?
Bei Dir
Hinter mir
Auf dich

IT CAME FROM OUTER SPACE

digital photograph and poem

GABRIEL DON

NEW YORK, NEW YORK

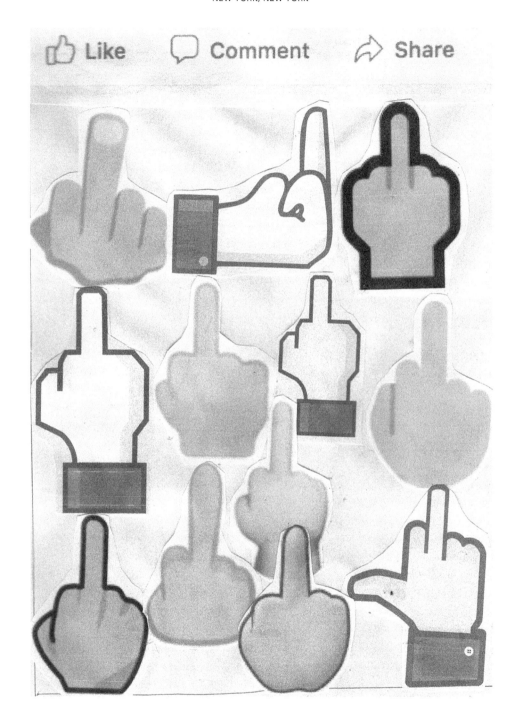

DADA DON

mixed media collage

RICHARD STONE

SAN FRANCISCO, CALIFORNIA

SNIP-OFF!!!:
FACEBOOK 'SNIPPETS', WHICH RESULTED IN DEFRIENDING/BLOCKING:

??/??/201?

The God/Jesus dichotomizers are the ultimate straw men, promulgating a bifurcated two-party theological seminary to out-fake each other with religulously inquisitional precision: the vengeful God Republicans vs. the altruistic Jesus Democrats, playing each other into a perfect downward spiral in the Social Darwinist rat-race to the top—as above, so below, Ain Soph Aur, indeed . . .

12/24/2015:

It's that type of existential diarrhea and verbal vomitissitude that keeps hate inflamed in the collective memory of the terminal magic carpet ride of convenience known as excessive holocaust revisionism, just for the sake of the collective punishment of the Palestinian people..

Dec 15, 2015:

It's a metaphor applied to the proliferation of other things I speak of in this thread. Is the teabagging reference, the pinnacle of your intellectual rejoinders to what I speak: artifice as a marketable form of carnival barking, to sell gallons of snake oil to fill up your conservative think tanks to fuel your sputtering machinations, clogging up all cylinders of both HEMI-spheres of your idling brain?

October 15, 2013:

Why not just build another Mount Zion Looney-Bin-Ladin asylum to house the Democratic Machine's Manchurian Candidates unable to handle the upcoming insurrection of Emperor Norton's 'Second Coming'..

March 28th, 2016:

A promissory note of your namesake is bounded as an illusionary intuition cloaked around the sheer deception of your character.

March 16th, 2017:

With an attitude like that, you'll get Trump in 2020 and Satan in 2024! Blametarding others for exercising their free will for voting for more a sustainable world, over business as usual that drags us into the pit, will not work no matter how you slice and dice it to placate your overinflated ego!

March 21st, 2017:

Your existential karma basket

BECKY FAWCETT

LINCOLNSHIRE, UNITED KINGDOM

LOL 28 MILLION TIMES

Yellow face and crying eyes
900 million love heart smiles
A Hashtag solidarity
Bliss my bestie Katy Perry
Jesus C comes after Justin B
Just **WOW. AMAZE**
Name your pronouns now you own them
The Minions, how they beat Kanye?
'Famous and White' has seven thousand likes
Those Narcissistic Parents. FFS
The unknown but hidden, **PUFFY AMI YUMI**
'I refused to give up' gets much SAD FACE
And 'Imaginary Boobs' wins **5** million hearts
'Shaving Cream Torture'
Rent-a-Llama, the Nexus 7
2 dogs got married, so many views
And there's 'Massage Envy' and 'Old Folk Selfies'
Infinite lists of Google hoaxes
Battle Baby Boomer Vixens
Are worried about their pensions
Or that they've eaten too much venison
88 million of us like sin
41 million are crying down their chin
Donald Trump's 'gone live' in a huge hall of mirrors
Laughing and shouting at himself
OMG

We LOL 28 million times.

PASCALE LE BIHAN

PARIS, FRANCE

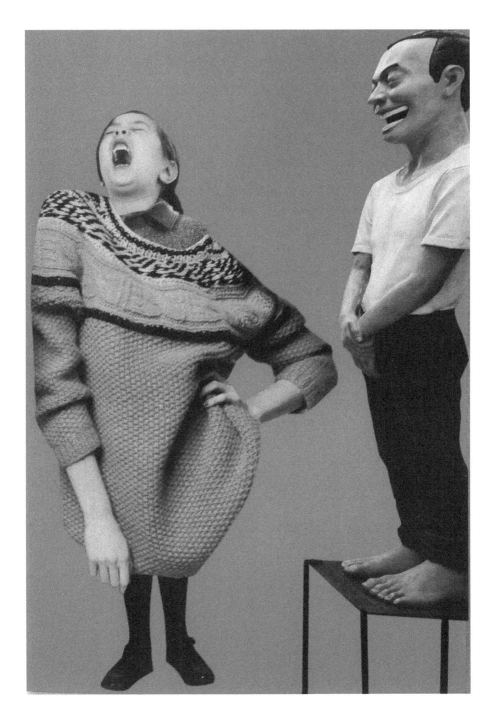

A LAUGH IS A LAUGH

collage, A4

DOUG KNOTT

LOS ANGELES, CALIFORNIA

FIN RE WALTER ROBIN
LIKE A HOLLYWOOD LAWYER

Poetry does not require cash.
Life and movies require cash.
Walter required a lawyer—
I required cash
And threw in some poetry to boot

Walter, an old-time indie movie producer
A phone-in-each-ear guy,
Talked twisty as a Mobius Stripper
Shouted, then made deals in a whisper

I, as lawyer, a casual bottom feeder,
Not tough but easy,
Enjoyed Walter, his hair slick
Just back from Cannes

Walter, an anaconda,
was too fat to get in my Mini-Cooper
But took movies to Cannes,
the big topless international film festival,
And sold them on a burnished yacht deck
Under a big bright breast of sun.
Distribution followed.
Burp.

We sat in the rented Laurel Canyon pool-house office
at the end of the sculpted blue swimming pool
Where stars once swam breast-stroke,
And Walter and I now contemplate astronomical sales.

People sued, but that was expected
even among the good guys.
However and needless to say,
no trademark, patent or copyright
Could catch our legal moonwalk.

I watched as clients entered the pool-house stage left.
There was a heave in the gabled structure
As they were consumed!
Out came Walter, brimming with contracts
I had copied from genius form-books

Relieved smiles by the swimming pool,
And odes in the 4-cornered prose I had composed,
All about "pay up," "trigger the loan," and who's to blame?
If you ever see the phrase, "Kindly be advised,"
Get out of town

On the blue blooming sky-way over Hollywood
An eviction notice pinned to the first cloud:
You forgot to pay on time? Who owns this dream?

MATHIAS JANSSON

ÅKARP, SWEDEN

 Kurt Schwitters aka Merz 5/15, 1:17pm
What do you dada my new poem 😵

bfbwfmsbwrefmsbewebeweretäfmsbewetäpbeweretäzäfmsbe
- E

 Hugo Ball aka Karawane 5/15, 1:17pm
Line breaks dude!!!!!

 Kurt Schwitters aka Merz 5/15, 1:17pm
Like...
b
f
bw
fms
bwre ???

 Hugo Ball aka Karawane 5/15, 1:17pm
👍👍

 Kurt Schwitters aka Merz 5/15, 1:17pm
What are you working on... 🙈🙉🙊

 Hugo Ball aka Karawane 5/15, 1:17pm
jolifanto bambla o falli bambla
großiga m'pfa habla horem
egiga goramen

 Kurt Schwitters aka Merz 5/15, 1:17pm
💩👍👍

DADABOOK.COM DIALOG

digital image

GEORGE WALLACE

HUNTINGTON, NEW YORK

THEOREM #17

using a can opener and marianne moore,
demonstrate that justice is a fish

1. i have a can opener in my kitchen drawer which i use to open up cans of peas;

2. peas: what marianne moore imagined she saw, standing on the precipice of a great agricultural valley, on a visit to california in 1939;

3. agriculture is the method by which we place civilization and its lies on the tips of our children's tongues;

4. lies are like peas, sometimes a lie is a circle so small you can get your tongue around it;

5. circles: like archimedes, marianne moore never saw a circle floating on the surface of bathwater she didn't like;

6. float: as in the verb, signifying the last act of one fish before being eaten by another fish;

7. in 1941 elizabeth bishop beat marianne moore so hard with a fish that she began to believe it was a stick;

8. sufficiently beaten, any human being will chase a thrown fish as if it were a stick, and return it to you;

9. a thrown thing must be returned, it is against the law not to.

10. justice is a fish.

CATHY DREYER

GINGE, OXFORDSHIRE, UNITED KINGDOM

HOW DO I CLICK 👍? (SONNET 43.1)

After Elizabeth Barrett Browning

How do I click 👍? Let me count the ways.
I click 👍 when I see thy stooges click
—I must keep my standing with thy clique
which clicks its 👍s for thy most trifling phrase.

I click strategically, just in case.
I click 👍 accidentally, as slick
as lichen. I click 👍 on maverick
dissent, and click some 👍s in all good faith.
And there are mercy 👍-clicks, when thy posts
hang 👍-lorn, shunned by them who once said thee
were most-👍ed. Un👍ing friends! They toast
their new Big Thing in viral 👍-stasy.
Thy name is un👍ed now. Thou art a ghost,
except to me, still clicking 👍, for thee.

JAMIKA AJALON

PARIS, FRANCE

MY HORORSCOPE LIED

all my friends are getting laid but me

think I'll have a cup of pitea

and Im uptight uptight

insomnia peppered nights

my horoscope lied

there is no love in these skies

yeah and all those white rabbits

I count left me to go ask alice

breaking the neck of that voodoo doll

when shes 10 feet tall

liquid diamonds and all

I mean I put on my best shirt

swallowed some ancient hope

and even on the best dope

nothing at all nothing at all

losing my sight and right hand

joined the legends in the sergent band aid

on afro samurai lemonade

I am penetrating the pulse

finding distance finding a distance

from the

paranoia rapping at my door

one two three four on two thre four

the marching brigade

has kettle drums and

I still cant cum still cant cum

getting bitter and twisted

cause though my hororscope insisted

(that I would soon be entering this post rose haze)

I aint listed these days

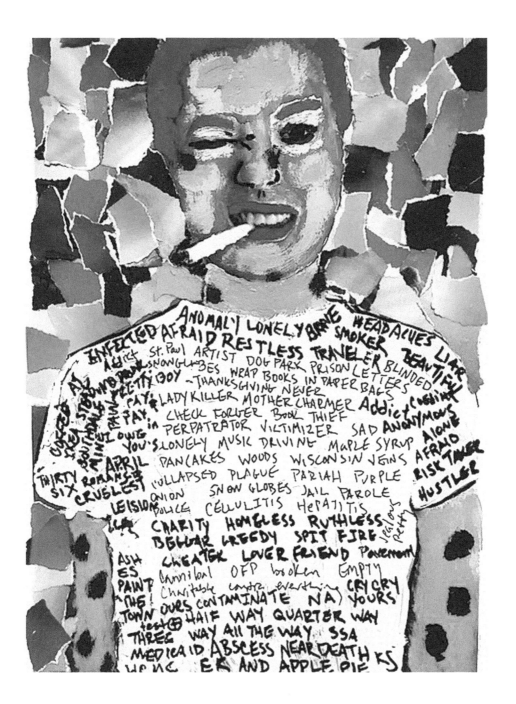

HARD TIMES CAFE

collage with gauche and acrylic paint, sharpie ink, torn paper from magazines, 9 x 12 inches

KATHLEEN REICHELT

LANSDOWNE, CANADA

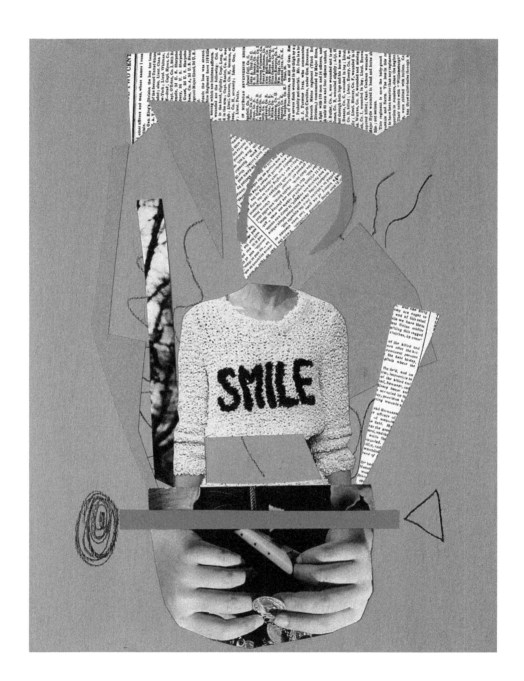

HYPNOTIZE YOUR THUMBS

collage, paint, graphite on wood panel, 9 x 12 inches

ADRIENNE MOUMIN

NEW YORK, NEW YORK

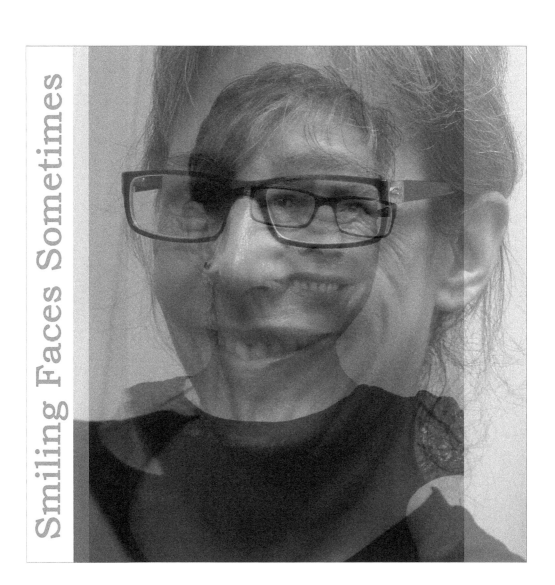

SMILING FACES SOMETIMES

digital photographs and text, 8 x 8 inches

ALLAN BEALY

BROOKLYN, NEW YORK

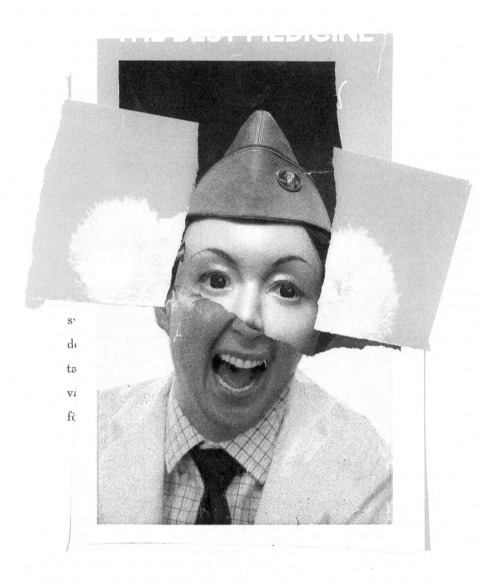

TO BE LIKED

collage, 9 x 12 inches

GERARD SARNAT

PORTOLA VALLEY, CALIFORNIA

ME, I LIKED EGGHEAD STEVENSON.

Back when Sis liked General Ike there were 2 choices at filling stations
where Super was better than Ethyl which was the name of a maiden aunt
who once was totally in love with Father, Mother said on the hush-hush.

Dad drove a 3-holed Buick Special, while his older brother had a Super
with 4 holes which drove Pops nuts that I was paid in instead of cash
for sweeping Gramps' drugstore every Saturday and Sunday morning.

Since Mom was constantly traumatized by fear a sibling plus husband
might be into hanky-panky, she could not manage our household thusly
her take-over daughter became the family matriarch at a very tender age.

RICHARD MODIANO

VENICE, CALIFORNIA

FOR/AGAINST

For workers on the line bored, tired and robbed of their creative
days;
For women raped, pinched, door-opened, decultured, feminized,
beaten, married;
For Blacks, Latinos, Native Americans, Asians, Queers . . . nameless, robbed
of dignity, lynched, harassed, low-paid, running, jailed;
For the drunks and addicts, the worn-out and the never lively, for the old and ill who should be long-lived
and wise;
For the young, schooled and unschooled, enduring boredom,
Getting stoned, stealing sex and losing love, trying to escape or trying to find a way in:
For those on welfare or off, looking in or looking out, employed or unemployed alone or in pairs,
hiding their sex or flaunting it, angry, sad, mad;
For **all** those who feel less than they could feel, for those who are less
than they could be in this rich land, the United States of America; and,
For the Puerto Rican, Chilean, Argentinian, South African, Libyan, Iranian, Syrian, and Pakistani
exploited, robbed, starved, cheated, tortured, ambushed, kidnapped, death squadded;
For all the world's citizens suffering brutality and indignity—the
electric shocks and murdered relatives, the starvation and the
working for pennies, the military boot and the cultural stamp—
For the empire's citizens; and,
For the empire's enemies:
For the strikers, the saboteurs, the feminists and anarchists, the
Marxists and nationalists, for those with no ideology but liberty;
For the memory of Durruti and the Spanish freedom fighters;
For the memory of Cabral and the liberation of Africa;
For the memory of Victor Serge and the Russians in revolt, for Luxembourg and the German left,
For Ho and the Vietnamese—the Vietnamese who 50 years ago taught us **all**
For Black Lives Matter, Antifa, Women's Liberationists, Farm
Workers, Puerto Rican Nationalists, for those of AIM and their
Relatives who resisted and died in the past and who nonetheless live
on:
For the ones who dodged the draft, for those who went and
Disrupted, and for those who went and died—or lived;

For the French in the streets of May and the Italians in Autumn, for
The Mexicans in the summer and Kurds and Chinese . . .
For everyone who has fought, fights, or will fight for a better
World than they were, are, or are going to be bequeathed;

And at the same time, necessarily:
Against the Trumps, Kochs and Putins, the elite CIA of the world, and the Kissingers all;
Against the doctors who deal in dollars but not in dignity, the landlords, the lawyers, and the politicians
with eyes closed to injustice;
Against the owners, administrators, bosses, rapists and racists,
those on top and those who aspire only to be there;
Against the dealers of bad hands;
Against the social ties and unties that breed the good and
the bad, that breed the pain and we who grow ugly by inevitably
"benefitting" from its continuance;
And last, for after all this is to be a poem;
Against the poets who keep art as if it were their
private property, who enshrine their own ignorance under false
halos, who can justify barbarism or technically dissect it as their
interests require—but who never shed a tear;
Against the media-liars, the news-pimps, the career thinkers, the
academics who propagate propaganda to preserve this system
the academics who call for justice and
always do nothing, the ones who succeed but don't stay angry,
the ones that don't really care;
it is time for all of us on the outs to talk of what a better world
could—will—really be like, that we might together make it so.
Till when there will be fewer acquaintances and many more
friends, lovers and first and last;
To those who have yet to live under economic equality though they have
certainly seen the last of capitalism--I dedicate this poem.

DEREK ADAMS

STANSFIELD, UNITED KINGDOM

BA DOM

Ba Dom
Ba Dom
Ba Dom
Brae z
Brae z

De Speep
De Speep
De Speep
Pol
Pol

Rrrrr

Rrrrr

Trum Pah
Trum Pah
Trum Pah
Sae z
Sae z

De Speep
Pol
Rrrrr
Ba Dom
Brae z

Trum Pah
Sae z

De Speep
Pol
Rrrrr
Ba Dom
Brae z

Trum Pah
Sae z

JANE LECROY

NEW YORK, NEW YORK

like a
nickel
like the
moon the
moon like
a giant blind
eye an eye
like a lake lake
like the sky sky
like a red cape
red cape like a tongue
a tongue like a fish a fish like
a tear a tear like a jewel a jewel like a
lens a lens like a roll of tape tape like linguini
linguini like luscious hair hair like a storm a
storm like a herd of g a l l o p i n g elephants a
herd of g a l l o p i n g elephants like a single
groundhog undulating across a field like a wave
a wave like a tipi a tipi like an A A like an arrow
arrow like a beak a beak like a pair of scissors
a pair of scissors like a butterfly butterfly like
tulips tulips like wax lips wax lips like real lips
real lips like double-hulled ships ships like seeds
dried up dandelion fluff like umbrella skeletons
parachuting wishes I wish you liked me like me
like is everything alike a like alike a lie

LIKE THIS

visual poem

MARINA KAZAKOVA

TONGEREN, BELGIUM

LIKE BALLERINAS FLYING IN GRAND JETÈ

Like ballerinas flying in grand jetè,
old film grains in midair,
white origami swans,
surreal alphabet,
melting punctuation,
hyphens and dashes,
handwriting of God,
the bible of nature,
just a cappella,
kisses from nowhere,
billions of eyelashes,
tombe la neige . . .
The debut of snowflakes
each year
grabs the attention of those
above the equator.
Just for an evening
caught by surprise,
we become all alike.
We are all a like—
in thunderous applause
under the facebook snow posts,
like the spectators of the Bolshoi
hundred years ago.

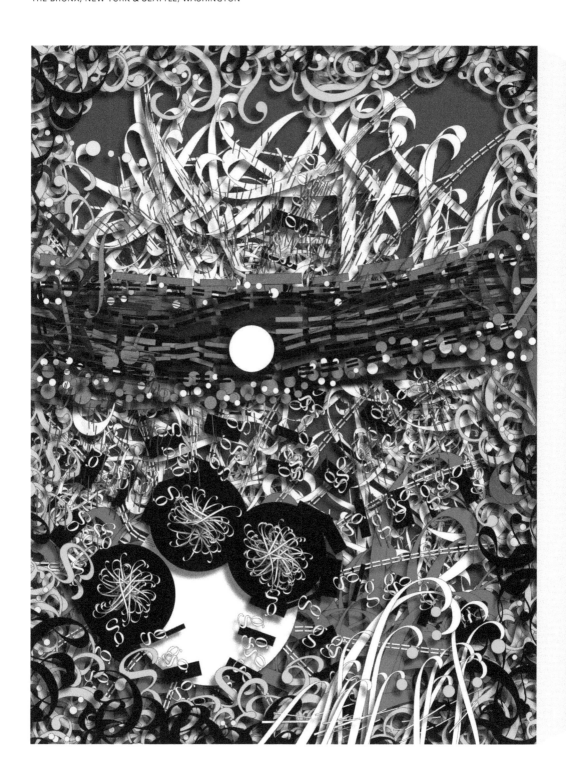

I know this feeling. It's called turmoil.

It attracts thieves & rebels. Here come the

woodwinds. No need to tell anyone. They'll figure it out.

Spinoza saw God as nature itself. And why not? Just look at what I'm

wearing. A tiara, a tutu, & a pair of dark leather gloves with a rabbit fur cuff. Don't

even mention cork. I'm up to my ears in cork. Would you like anything? A glass

of water? You've come this far. Later, when we've gotten to know

one another a little better, I will show you my favorite

feeling, which is weightlessness in the

hallway where voices echo.

COLLABORATION TWO

digital image: Nico Vassilakis; text: John Olson

JOE DREYER

GINGE, OXFORDSHIRE, UNITED KINGDOM

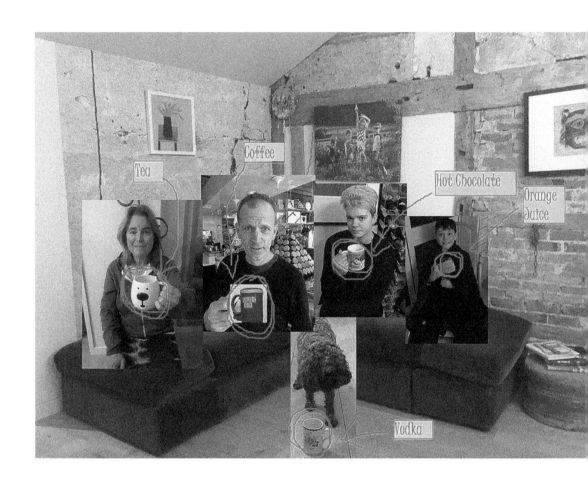

FAMILY LIKENESS

digital photograph

MICHAEL C. FORD

LOS ANGELES, CALIFORNIA

FAMILY REUNION

I am like you, Pa: an intricately
carved oak boat: drifting over
kitchen linoleum oceans nurtured
by their main source: cool thin

streams from aluminum estuaries.
Since I was a boy, bizarre memories
comfortable as bedrooms have been
buried by sand-colored suburban

neighborhood accessories: not gold,
really, not strange stones, but imagined
fishy shapes sunken under pastel lakes
of wall-to-wall carpeting. And, through

our days, I drifted in dawn wind down
hallways exhibiting photos of childhood
homes, where there were too few cool
mornings, nor few glances at glamorous

skies, nor warm summer stars: all that
can compare with what insulates me. I
use for anchors doorstoppers or porch
lights. For oars I use table struts, chair

limbs. In order to see myself reflected in
remembered waters, there is a necessary
backstroke to dark perimeters of backyard
riptides that maintain appearances of being

thoroughly intimidated by marginal treasures
located where Ma had secreted away her sacred
memories almost as though they were private
pirate contraband.

PAMELA PAPINO-WOOD

YONKERS, NEW YORK

BLIND LIKENESS

There is something deep down that drives me
Some days I call it confidence, other days I call it optimism
But most days it's called insecurity—that feeling of not being good enough
The child that got beaten and abused by family, friend, father, cousin, and uncle-alike

I walked the halls and streets and hallow spaces of my mind to escape
The only reprieve lay between the lines of black and white
I soaked up and created as many as I could, and painted my verses vivid
Like the memories turned into the reality of my adulthood

I post my colors with smiles and fortune no matter how gray my world might feel
escapes to warm breezes and higher achievements, camouflaging the unsettled within
this reinforcing behavior of seeking approval of things that don't matter
just so I can hide within my own skin

Are we ever more than the darkest parts we run from
Trying infinitely to portray our version, of what we expect our reflection to look like
Improvement, progress, positive productivity, infectious disillusionment
Cyclical patterns of unhealthy Zen seeking spirituality

We are constantly reaching outside of ourselves, to God, to science, to art
And counting the lessons, and inspirations, of the things that set us apart
believing our honesty is based on more than just perspective
which blinds us all from seeing how much we are really just a like.

PATRICIA LEONARD

YONKERS, NEW YORK

ADDICTED

Slow jams in my head
On a Sunday
Overthinking while you're away
My body's paining me
All awhile my mind is suffocating

And I know you,
You shoot through every vein in my body
But we worry about the wrong things
In times of need you are who I reach for
And what am I to do
Now that I'm here without you

All I need is a little TLC
Rolling around in the bed
Wrapping myself in sheets
Because I'm withdrawing from your love

We are like the crack head on the corner
Wanting to be loved
Suffocating amongst the large crowds
Looking for a place to slip in and hide away
Our inner demons.

But we bring us wherever we go
And just like the crack head
Seeking inner peace in isolation
We all shut out the world

Because I'm jealous of the way you're
happy without me

LOIS KAGAN MINGUS & ALFONSO IANDORIO

NEW YORK, NEW YORK

DEFINED, AMPLIFIED, QUESTIONED

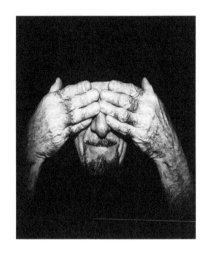

Broken by the weight of these days because
immigrants are banished or expelled

or by his distorted orange face, spewing, spouting,
smirking, masturbating with complacent glee

or another hand where it shouldn't be, rubbing, drooling, denying,
the victim in shadow, the child grown, suffered and suffering

or the church, the mosque, the temple, targets all,
solo or organized, self-inspired or directed, the gun, the bomb

or homelessness racing beyond it's definition

or crashing cars, intentional and accidental

or newly invigorated racism, bigotry, homophobia,
nurtured, encouraged, promoted

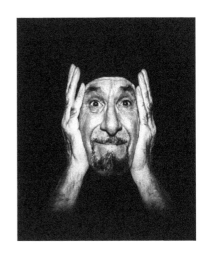

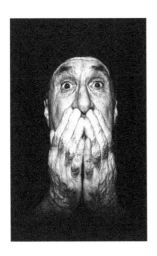

or

are most of us thinking the same decent way,
alike in our actions.

Splinters removed, bandaids disallowed,
engaged, resolute, unshakable.

LINDA LERNER

BROOKLYN, NEW YORK

A KIND OF LONELY

I think across three billion miles
to locate Pluto bring it down to earth
 to figure out what all the hype is about
but cannot get around its icy mountain air
with its flat desert like surface that
makes me think of someplace out west
where people once got lost and died,
searching for gold, coexisting,
then there's Charon, that underworld ferryman
circling it whom I cannot get away from
and shudder. . . . no place
I want to be . . .
I try to send it back where it belongs
but that nagging business of
its improbable journey to be defined
throws it right back here on earth
with all those called other coming out
 of whatever place they've
been hiding in, who've
crossed lines, whom nobody could
figure out if they're this or that
then you're nothing my mother once said
on hearing that I don't follow
my birth religion, believe in its god:
someone or nothing
mad person or genius,
planet or no planet
so it goes, around & around

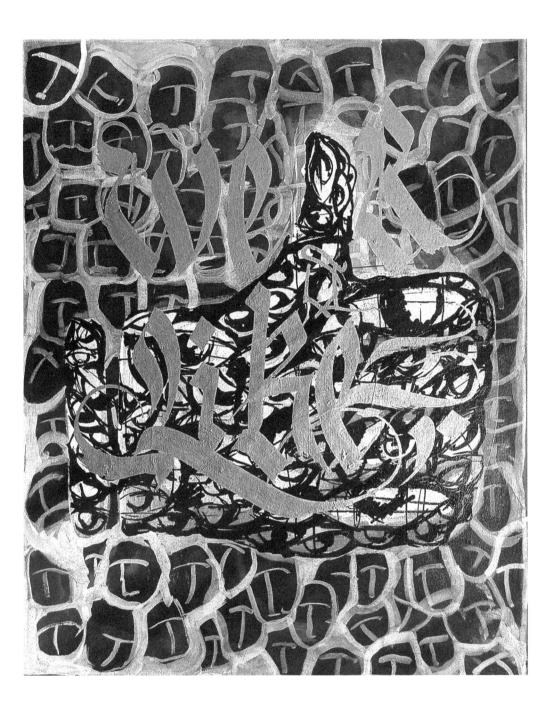

WE LIKE WHAT WE SEE A"LIKE"

acrylic and ink on canvas, 50 x 70 inches

GIOVANNI FONTANA

ALATRI, ITALY

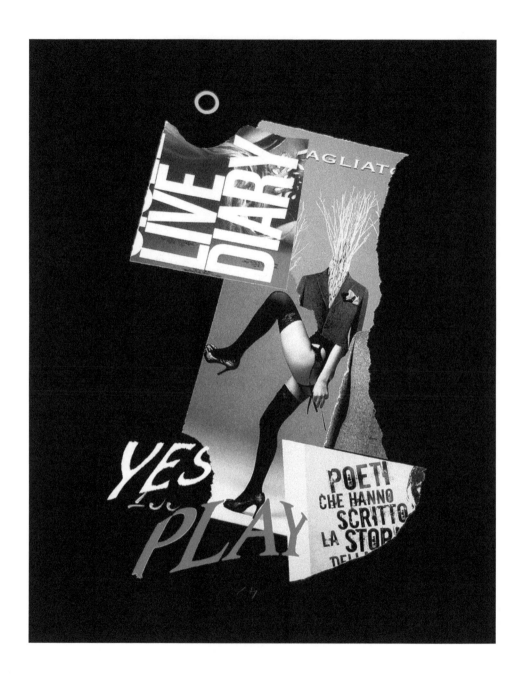

YES!

visual poem

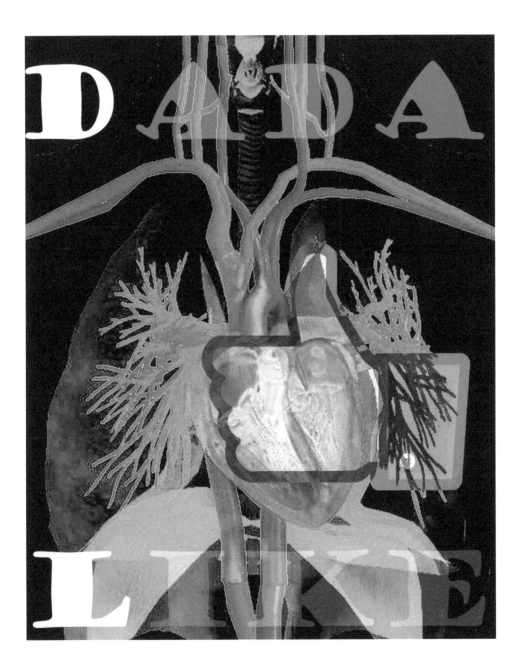

DADAISM-ORGANISM

digital art, 4 x 5 inches

ANTONIA ALEXANDRA KLIMENKO

PARIS, FRANCE

H-OURGLASS

i'm not what you think

i'm everything i'm not

in truth *you can see right through me*

ethereal breath

transparent grace

a colorless face

you're not yet fully aware of

but

if you held me up to the Light

you would know

how really in tune we are

how translucent our death

our weightlessness

as we float like the moon

through celestial lands

molecule by molecule

gliding

from echo

to echo

chamber

to chamber—

a nautilus winding

a clock with no hands

CSABA PAL

BUDAPEST, HUNGARY

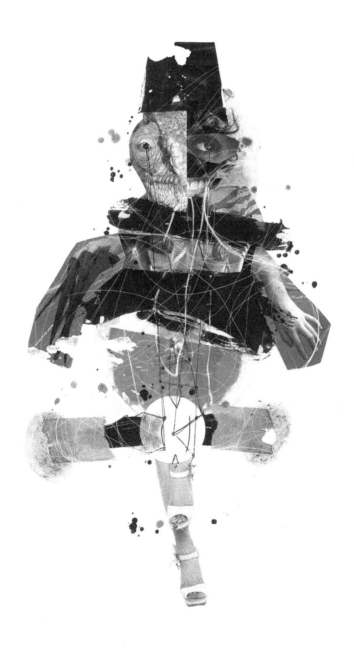

SOUNDLESS

collage, mixed media on paper, A4

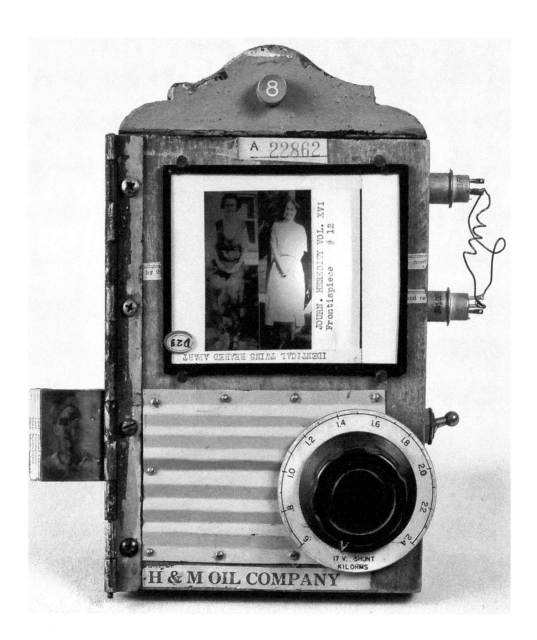

IDENTICAL TWINS

mised media illuminated box, 7.5 x 9 x 2.5 inches

WILLIAM SEATON

GOSHEN, NEW YORK

UNTITLED

My social circle's grand and good to me.

Thumbs up! – just look! – one more! – they are all mine!

Ah! Electronic friendship's fast and free,

and we can use an icon for our sign

and think much less than crafty garden toads –

no hesitation, wariness, or fuss.

For we all *like* to travel on this road.

Those microcircuits are what's thinking us.

CAROL DORF

BERKELEY, CALIFORNIA

IN TRANSIT

I wanted to use the word liminal

but my friend, Martha, told me it was too

academic so I debated between

transitional and transaction.

One academic, two academic,

but who's counting. My preference

would be transcontinental, that way

when one country was in the midst of quakes

you could flee to another. Whatever she said,

I was never ever intransigent,

though I should have probably worked harder

to translate transitional states of feeling.

Who are you? she asked. *Just another*

transient looking for likes I replied.

FAITHFULL BAANA ENONO ARNAUD

YAOUNDÉ, CAMEROON

ETRE HEUREUX

On a tout pour être heureux
Mais on fait tout pour être eux

Le paraitre, le peut-être
Surtout ce qui ne faut pas être
Eux qui sont fanatiques du suivisme
Depuis il passe en boucle le même disque
Mais personne n'a perdu l'appétit

On a tout pour être heureux
Mais on fait tout pour être eux

Cela qui ne cesse de coller la petite à la bêtise
Merci daphné à la précarité dès lors nous sommes calés
On vend tout pour mieux disparaitre
Ensuite en rêve tous d'aller chez eux
Hélas ! Même la mer nous parle d'immigration choisie
Combien on perdue la vie sur ce chemin?

On a tout pour être heureux

Mais on fait tout pour être eux
Maudit est-il mon teint ?
Fini les câlins du chagrin
Oh que si le pain perd de plus en plus sa mie en Afrique
Nos pensées ont tous des visages Schengen depuis la nuit des temps
Le sud comprendra peut-être quand il y'aura embouteillage d'avion dans le ciel

On a tout pour être heureux
Mais on fait tout pour être eux

Autre fois bétails
Le défi est de taille
On se vend en détails
Toutes nos réflexions chaussent des petites pointures
Mais un point levé vers le futur
Ton sourire tu l'auras à l'usure

MALIK CRUMPLER

PARIS, FRANCE

SAINT MICHEL'S PASTIS

The Lie was sick of itself, again

Went to the bar & ordered

Pastis after Pastis & was just

about to order a Monkey Shoulder

when the Pastis protested,

"Regarde, mon ami. I believe in

monogamy. So, doucement."

The Lie smurked, "So, you're a believer?"

Pastis grinned, "I know what I know."

Lie countered, "you ever get sick of being?"

Pastis frowned, "Being what, a bottle?"

Lie nodded

Pastis said, "Only thing I get sick of, is being empty-"

Lie jabbed, "-If ever you need someone to fill your vacancy I'd-"

Pastis stabbed, "We fill ourselves with mourning all the elixir

you've abducted, tu as compris?"

Lie laughed, "Mon frere, I believe you've lost your mind along with all your-"

Pastis lunged, "Non, you drank my spirit and now I must-" And shattered on the floor

Everything in the bar turned in The Lies direction,

Lie said, "maintenant, that didn't happen."

Whole bar nodded, forgot it & sighed, "Pas grave." And turned back around.

J. C. HOPKINS

BROOKLYN, NEW YORK

THERE IS IN THAT

something worth looking at

if i could only open the flap

counting days is like

crying

only more slow

the bashful enterprises

have a way of blossoming

unexpectedly

by surprise

rather than

by flare

which is best

conforming to youth

by socking away

eccentric tendencies

and one day

i will

and you will

let loose these leaves

and know

that we are evermore

strangers

BEATE BENDEL

BERLIN, GERMANY

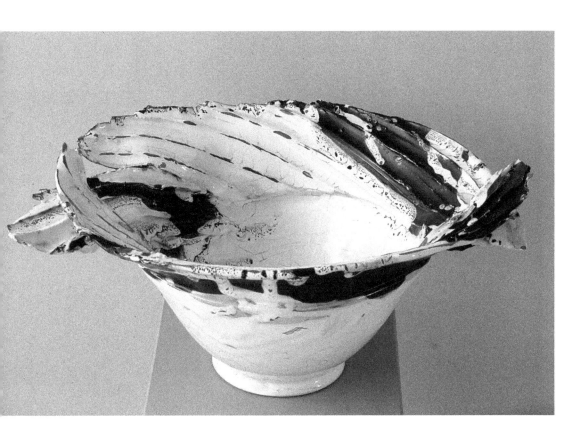

BLACK SWAN

clay, stoneware, faycence, and black glaze, craquelée, platinum, 42 x 33 x 20 cm

SANDRA GEA

FONTANA GOZO, MALTA

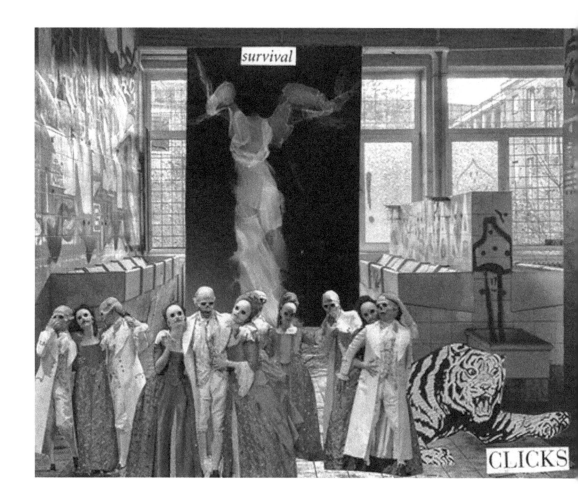

POLLICE VERSES

analog collage on paper, 5 x 4 inches

A. D. WINANS

SAN FRANCISCO, CALIFORNIA

AT 80

You realize we're all alike
That you're not immortal

Parents long buried

Friends fallen by the wayside like

Spring leaves from aging trees

Arthritic Bones that creak and moan

Mile walks turned to blocks

The years flee like a thief

In the stillness of dawn

Bring me to my mother's grave

Her tombstone chipped

The words fading

No such fate for me

I'll go the way of the Indian
My flesh given to flames

No dirt No worms
No suffocating box

Ashes and bone my fate
Monterey or San Francisco Bay

The sunset my headstone

My poems my marker

CARLA BERTOLA

TORINO, ITALY

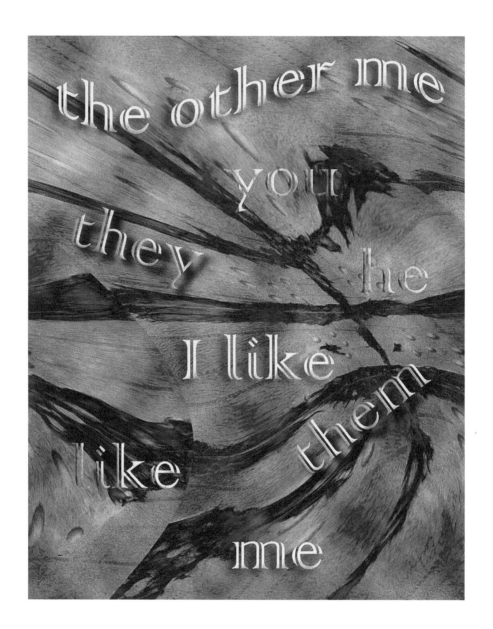

THE OTHER ME

digital work on previous collage, 4 x 5 inches

philipkevinbrehse

BERLIN, GERMANY

38 DEGREES CELSIUS . . . QUESTIONS

for Michael Steger

you died fifty-eight days ago
 and now 2,985 crisp dead leaves clatter up the cobblestones
 clickering in spirals up this slight hill in Chisinau town
 stirred by this monstrously hot wind . . . it seems to be you
 these yellowed leaves which play together the symphony of skeletons
 aroused by their dance with one another . . . their little stems erect
i try to recharge and restore with this freshly pressed apple juice before me
 served by this exceedingly well-built and equally juicy redheaded boy with freckles
 it is deliciously sour . . . but sadly not cold
on the outskirts of the city
 on the hills near the wine groves where grapes rot on their vines
 in every village
 the dogs howl . . . singing their miserable orotorios of desire
looking up to see
 i feel screams coming out of the half closed windows above
 hung with dusty russian plastic lace curtains
 smelling of cigars and stained from the teary wiped out eyes
 of those who looked down to the boulevard for decades
 seeing only the deadness of it all
i try to read . . . for me there is only one book now
Georg Büchner – Woyzeck
franz and andres go to the "horse and stars" tavern
 . . . these words alone set my fantasies reeling in this heat
 my eyes remain hypnotized by one line of stage direction
 in my folly i think i'd like to do that too, with you
 fall through the doors of the "horse and stars" with franz, andres and you
 become engulfed by a theatrical nightmare
 androgynous masked creatures throb and lick and bite us
 two lads beat each other to the pulp because of whiskey and poetry
 perhaps the redheaded waiter will go with us
 he does smile at me so nicely . . . with pity?
 i don't mind i've gone mad
here at the cafe' in this oven
 the lads and maids parade up and down with trays laden with poisons
 on a catwalk mistaken for life and false movements do so mesmerize me
 in my carefully concealed madness i am at peace by this fountain
 yet on the periphery the mafia bosses are watching my every glance
 i feel in readiness to be grabbed from behind by the shoulders
 and thrown nose down onto the pavement . . . for breaking laws with my eyes
 for admiring the asses of their sons i hear you laugh at me . . . you warn
i do not know if this is fiction non-fiction poetry hallucination or nothing
it is only this . . . a dance
 a dance with you my dead lover
 like these crisp chisinau leaves
 dancing in hot wind
 they are we
 do you like this?
 do you see us now too dancing dead leaves?

VALERIE SOFRANKO

PITTSBURGH, PENNSYLVANIA

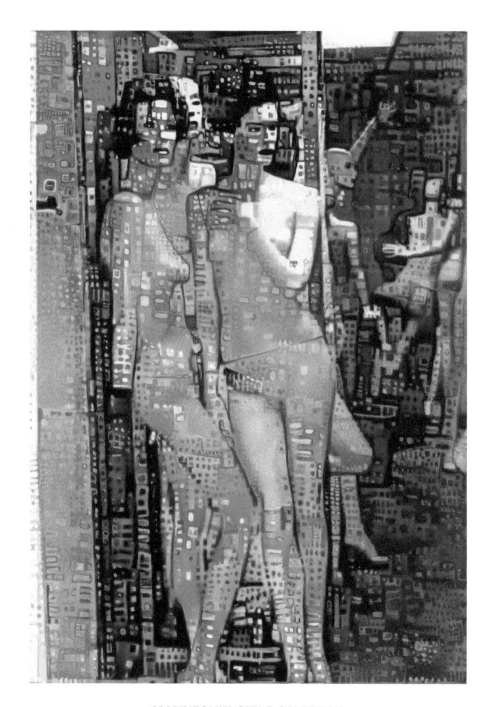

MANNEQUIN GIRLS ON BREAK

digital photograph enhanced with texturing and photoshop on special photographic paper

ANN FIRESTONE UNGAR

NEW YORK, NEW YORK

LIKE LOVE

When she was sixteen, he distracted her,
she, protracted across the landscape of feeling,
ricocheting on a valley floor like a rough pebble in a landslide.
What to do? What to do?
He fell hard for a physics major who married a Nobel Prize winner,
so he toughed it out on drugs.
She didn't like him at all finally,
though her acid trip, courtesy of him, was truly fascinating.

When she was seventeen, they, in pajama tops, on the floor of his basement on pages of the
Baltimore Sun ate an enormous bag of soft shell crabs sloshed down with a six-pack of Colt 45,
talked Rimbaud, tried to do it then, and years later tried again.
He loved her. He was lovely. He married well. Like, with a capital L.

When she was twenty, a rich man with manners asked, in the dark, "Are you offering me your
breast?" She didn't know. And "Have you read *Lord Jim*?" No, she had not, so she didn't answer.
She liked him, but not enough.

At 3am la bête en nuit—the beast in the night—arrived to listen to the sound of her voice
on the telephone, just listened to "Hello?"
What did he hear for about a year? High heels on pavement at midnight?
Figuring out who it was, she, conflicted, despised him though the world adores one of his movies.
Consider the chasm between the character of the artist and his or her work.
Like? Well, let's vote on it sometime.

After that, the man she adored
allowed her to tie him to her kitchen chair from a distance of 3,000 miles.

AVELINO DE ARAUJO

NATAL, BRAZIL

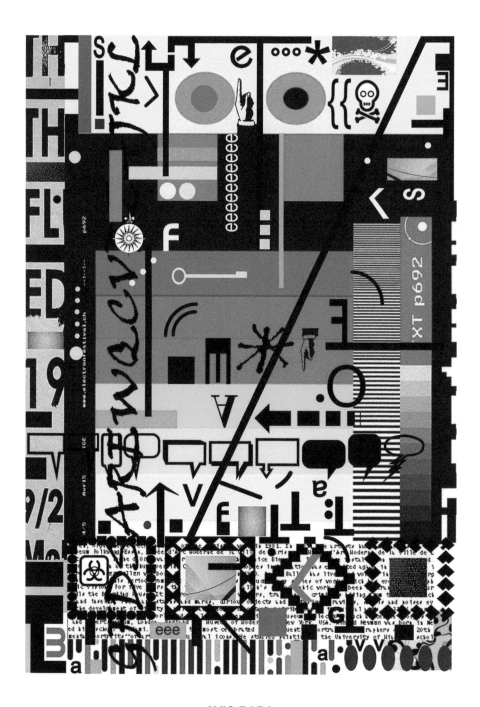

AVIS RARA

digital collage

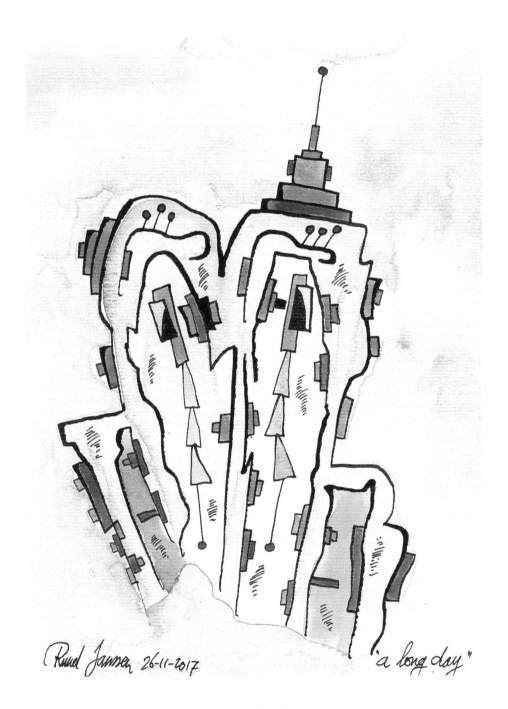

A LONG DAY

indian ink and watercolors on 250gm2 paper, A4 (21 x 30 cm)

BRADLEY RUBENSTEIN

BROOKLYN, NEW YORK

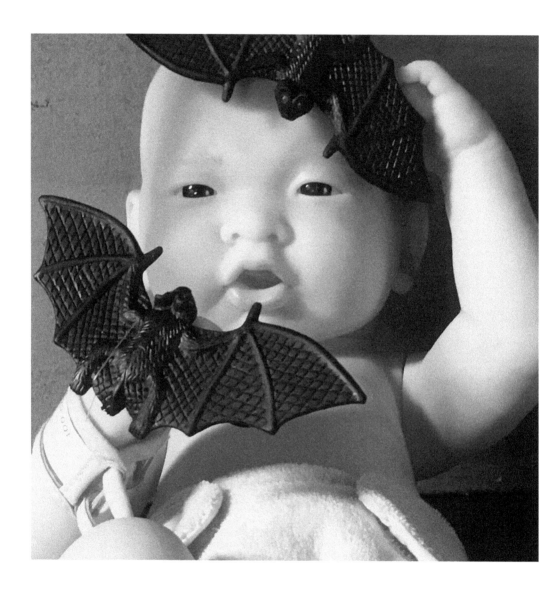

CHILD MENANCED BY BATS (INSTAGRAM POEM #19) 2017

digital image

SUZI KAPLAN OLMSTED

PORTLAND, OREGON

PROUD FLESH

(homage to Jane Hirschfield)

Babies are boring to me

I'm aware it's an unpopular opinion

I don't thrill to the beauty of youth

Who cares about clay before the sculptor touches it?

No one goes to prison for the theft of young diamonds

It's time and unimaginable pressure that makes gems

And seemingly endless irritation that forms pearls

Scar tissue may be beautiful

A map of triumph on our skin

A host of medals, for our courage

But young scars are open wounds

Bravery sounds better told in past tense

I miss my gall bladder and original esophagus,

my shoulder before two surgeries had sliced it back and front,

my ankle with its whole connective tissue,

and the bones in both my feet in mint condition, no titanium or screws there at my birth

I don't remember my breasts or hips before the stretch marks,

or my arms & legs before the scars,

I don't like my earlobe, torn from an old piercing,

and one tattoo you'll never see, I got while drunk at 22

But if I believed in heaven, if I got there, I wouldn't look 20

I earned every inch of skin I wear today

Though I'd hope it wouldn't still hurt to have them

I like a happy ending for my heroes

ANOEK VAN PRAAG

NEW YORK, NEW YORK

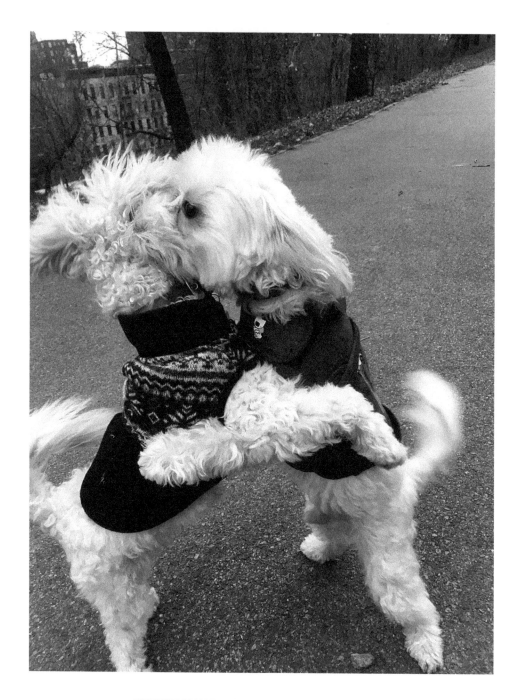

WHERE HAVE YOU BEEN ALL THIS TIME?

digital photograph

We Are All A Like

We all like it Nous sommes tous un comme We are all one
Isika rehetra dia mitovy We all are the same நாங்கள்
அனைவரும் விராம்-ாகிறோம் আমরা সব একটা ভাল ।
আছে We are all very similar Tanan Kita Tanan **We're All Right**
Ndife Onse Ofanana We Are All Equal અમે બધા એક જેવું છે
We are all like one हम सब एक जैसे हैं We are all alike
نحن جميعاً مثل We are all a like 我口都是一口的
We are all the same Мы все похожи Dhammaanteen waan wada
wadaagnaa Мы все это разделяем We all share this
Dhammaanteen waan wadaagnaa tan Όλοι μοιραζόμαστε αυτό
Kita kabeh nuduhake iki Peb txhua tus koom qhov no
We all participate in this Մենք բոլորս
uw մասնակցում ենք We all share this מעד ורייט עלא רים
आम्ही हे सर्व सामायिक करतो We share it all Wy dielde it alles
Við deildum öllu we shared everything
يوم خه رشري لرک Kami berbagi segalanya నామ
ఎల్లవన్నూ ಹಂಚಿಕೊಳ್ಳುತ್ತೆವೆ Muna raba kome Peb qhia
txhua yam Wir teilen alles Re arolelana tsohle We share all
우리는 모두를 공유한다 ሁሉንም ነገር እንጋራለን Em her tişt parve bikin
Nous partageons tout Бид хуваалцдаг Ka tohatoha عي ج ز و ت
Pipin... Shared... we are divided... we're sharing

we are all sharing

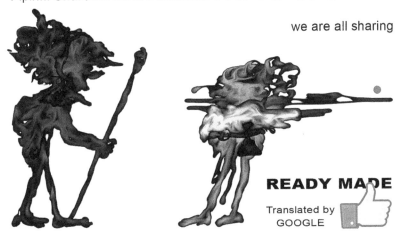

READY MADE

Translated by
GOOGLE

WE ARE ALL A LIKE NO. 1

digital text and illustration

LIKE CRAZY, MAN

digital collage

GORDON GILBERT

NEW YORK, NEW YORK

WHAT'S NOT TO LIKE

So I'm, like, not on Facebook.
So what?
Like I don't already
Spend too much time online.
Like I need to know
What friends may like,
Who are, like as not,
Not really friends.

Why should I, like, care
What they may like or not,
If I post something
For the world to see;
Like that's how I want others
To show they like
What I like or do or say.

I DIS-like social media
That, like, reduces all
To like or not,
The shallow surface of relationships,
UN-like deeper feelings
Like LOVE or HATE;
Like keeping score,
Tabulating "LIKES",
Should mean more.

Friendship should mean more
Than keystroke, mouse & clicking buttons
To "Friend" , "Un-Friend" & "Friend" again.
Friendships are more
Than "Likes" you tabulate,
And Friendship's meaning is
Like, demeaned,
Like diminished.

So you may ask of me,
"What's not to like?'
I will reply:
Only on Facebook
Are we all a "Like"
So I am not on Facebook,
And that is why.

RUTH OISTEANU

NEW YORK, NEW YORK

BIG GIRLS DON'T CRY

collage on paper, 8.5 x 12 inches

FORBIDDEN PROUD, WE ARE ALL A LIKE

collage, 30 x 35 cm

EDWARD KULEMIN
SMOLENSK, RUSSIA

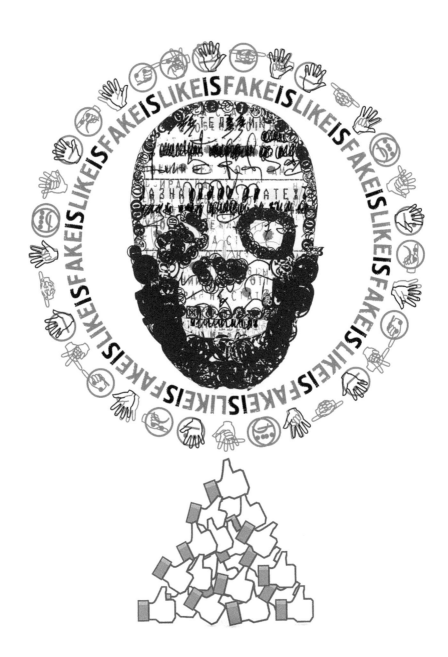

LIKE IS FAKE

digital art, 2480 x 3508 pixels

ANATOLY KUDRYAVITSKY

DUBLIN, IRELAND

DADA PERSONALITY

You are going to say what goes unsounded.
The flute of a mute will answer.
Also, the walking billboards
(after a brief consultation.)

You've learned from a birch
how to jive, and your cat
has taught you some Descartes.
You like not what you like
but your ability to like, n'est-ce pas?

You like "body." Any marble body.
Spilt (split) thunder.
The sky drinkable on the brinks
(a blueprint for delectation
of a gap generation.)

What else exists
in the sense that time exists?

The mind trembles seeing a treble clef
placed before every thought.
The soul grows fidgety fingers
to solemnise solutions.

The choice is yours.
Don't cast votes. Cast flowers.
Elect your daily undertaker.

WHO SENT US?

alcohol sent us and

the moon sent us and

the job sent us and

terrifying lectures about

eternity sent us and

the poem sent us and

the newspaper sent us and

the horror sent us

rushing rushing rushing rushing

rushing back to

each other to

each other

oh god bless this

reorganization of our fury

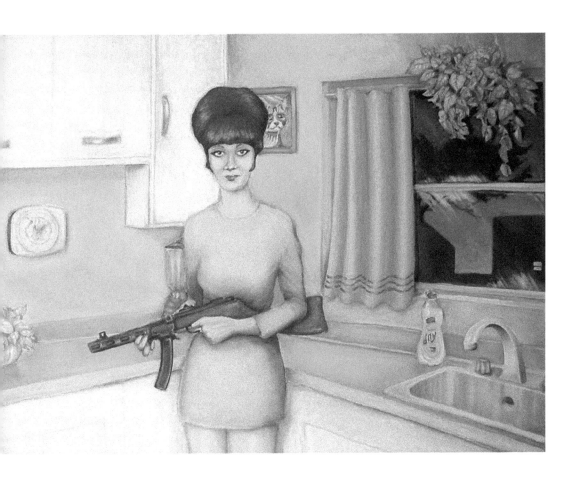

KITCHEN ACTION

oil on canvas

JAN MICHAEL ALEJANDRO

ALTADENA, CALIFORNIA

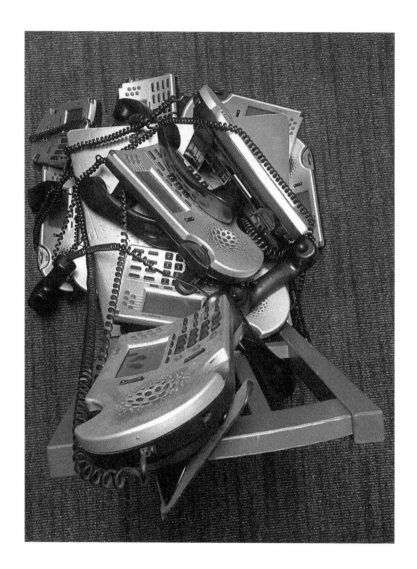

CALL ME

digital photograph

MUTES CÉSAR

ARCOS DE VALDEVEZ, PORTUGAL

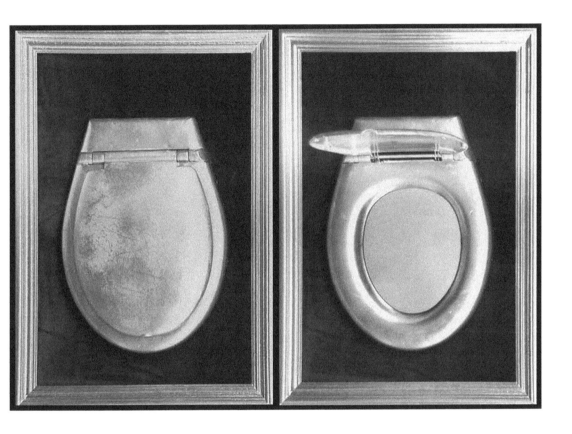

**THIS DADAIST ARTWORK WHERE DIFFERENT MATERIALS
WERE USED SHOWS US THAT ART CAN BE MADE FROM THE
RAW MATERIAL WE USE DAILY. UNLIKE DUCHAMP. . . .
HERE, A TOILET LID WAS USED, WITH A MESSAGE TO THE
''NOUVEAUX RICHES' WHO BELIEVE THEY CAN BUY EVERYTHING,
ON ACCOUNT IF THEIR FINANCIAL STATUS, EVEN THOUGH
THEY MIGHT NOT HAVE THE BEST OF TASTES.
THE USE OF GOLD AND VELVET IS PURPOSEFUL.
WHEN WE OPEN THE LID, WE VISUALIZE OUR OWN REFLECTION**

reflexes of your self, spray on toilet seat on wood and vevlet, with incorporated mirror, 78 x 58 cm

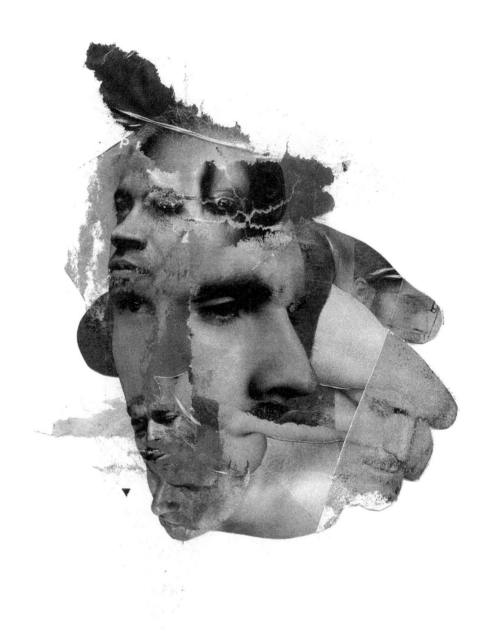

EGO

collage, 210 x 297 mm

THOMAS FUCALORO

STATEN ISLAND, NEW YORK

THE UNLIKING

Like the tax benefits you will not receive

Like the toupees with bodies who will

Like the class of middle lower back aches

Like the spirit risen from those who have fallen from lower back aches

Like the ache that has risen from lips

Like the people who rise to kiss those lips

Like the people who don't like you back

Like the science that proves their math wrong

Like the math that proves their science wrong

Like the nature that proves it all wrong

Like the ocean as it spits apart the rising it's drowning against

Like duh

Like me

JOHN S. HALL

NEW YORK, NEW YORK

ON BEING "LIKED."

1.

I recently posted a post
On Facebook
That got over
Three hundred likes
And yet I don't feel well liked
Let alone loved

2.

A like is like a bitcoin
It only has the value
People believe it has

3.

When people in my life
Pass
And I post about it
I feel somewhat less alone

4.

Facebook was founded
By a sociopath
But here we all are

5.

I believe it was Barney who said
I like you
You like me
A Facebook prophet, he

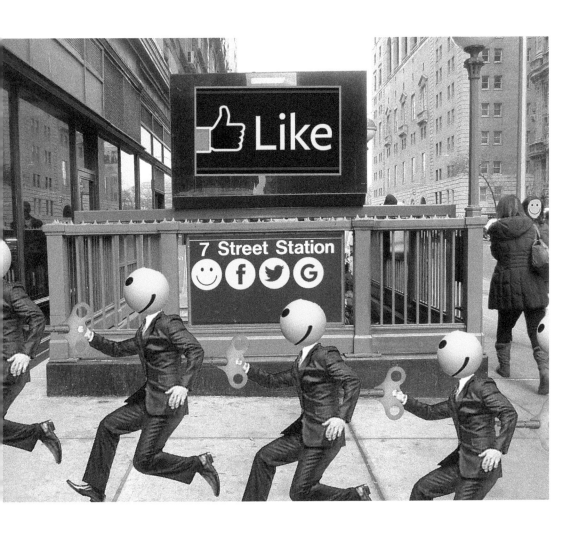

TWENTY THOUSAND FRERES ON A ROUTE

digital collage, 4.8 x 4 inches

JOHN J. TRAUSE

WOOD-RIDGE, NEW JERSEY

WHICH DO YOU LIKE BETTER?

TRUE VERSION
KOOKY COCHLEARIA

Nam et idoneus sub dio sumendus locus cochleariis, . . .

M. Terentius Varro
Res Rusticae *III 14. 1.*

Salvador Dalí in his Rainy Taxi (taxi pluvieux)
in the forecourt of the Galérie Beaux-Arts
for the Exposition Internationale
du Surréalisme in 1938, Paris,
included live edible snails slithering and sliming
over the female mannequin
in a tousled blonde wig and evening gown
in the back seat of the decommissioned taxi cab,
surrounded by heads of lettuce and chicory and a sewing machine,
live edible snails slithering and sliming,
while water pumped through pipes
rained down on her and the driver in the front seat,
a doll, whose head was framed by the mouth of a shark
and whose eyes were covered by a pair of dark glasses.

Patricia Highsmith, nigh high,
once attended a party in London
accompanied by her "dates",
a large pocketbook containing snails,
which she fed lettuce throughout the evening.

caracol . . .

car(ac)ol . . .

carol . . .

car . . .

Q – Why did the snail put a big S on his car?
A – He wanted people to say when he drove by,
"Hey, look at that S-car go."

WHICH DO YOU LIKE BETTER?

FALSE VERSION
KOOKY COCHLEARIA

Nam et idoneus sub dio sumendus locus cochleariis, . . .
M. Terentius Varro
Res Rusticae *III 14. 1.*

Salvador Dalí in his Dream of Venus,
funhouse and mad surrealist pavilion
at the 1939 New York World's Fair,
Flushing Meadows, included live snails
slithering and sliming in the dry tank,
among the pools with live nude models
covered in seafood ("living liquid ladies")
in the wet tank, bizarre sculptures,
rainy taxi, silk sheets, satin drapery,
pink plush, rose blush, mirrors within,
buxom Botticelli's babe beckoning
passers-by at the portal, live snails
slithering and sliming in the dry tank.

Patricia Highsmith, nigh high,
once attended a party in London
accompanied by her "dates",
a large pocketbook containing snails,
which she fed lettuce throughout the evening.

caracol . . .

car(ac)ol . . .

carol . . .

car . . .

Q – Why did the snail put a big S on his car?
A – He wanted people to say when he drove by,
"Hey, look at that S-car go."

NOTE: The epigraph may be translated into English as "In fact, a suitable place in the open air must be obtained for snail beds".

GIL FAGIANI
1945–2018

SMELLS OF REJECTION

An editor sits in a cab.
A writer approaches with a manuscript.
Peanuts and bug spray.

The editor whispers to the driver.
The cab shifts into first gear.
Sauerkraut and cigarettes.

The writer breaks into a run.
The cab's windows close.
Jim Beam and Doublemint.

The clamor of horns and whistles.
The writer fades into traffic.
Exhaust fumes and dog shit.

PAUL SIEGELL
PHILADELPHIA, PENNSYLVANIA

ENTITLED

You can skip
to video in 5

You can skip
—C'mon

You can skip
to—

 aaahhhhhhh

1

 —Finally

"Shy Octopus Hides Inside Its Own Tentacles"

 Awwwwww

VOXX VOLTAIR

OAK PARK, CALIFORNIA

UNFOLLOW

Buddha meets Himself
On the road
Sees a stranger
Who reminds him
Of The Cosmic Joke

He laughs
Knowing
The sound of
One hand clapping
Is a slap in the face

DD. SPUNGIN

NORTH WOODMERE, NEW YORK

MIGRATING EGO

Faint cry of geese leaving for second homes
Or are we their other
What does it mean to be first, preferred, favorite
Some don't think about position
Fly as seasons dictate, stand where the sun shines
Move as need moves them
Not heeding the others directing traffic
No hunger for the A plus, the endless love
Strangled by starvation
Starved for attention
Submission, a cheap price to pay
But not a guarantee
Where have the geese gone?
Do they miss me?

RAF CRUZ

LISBON, PORTUGAL

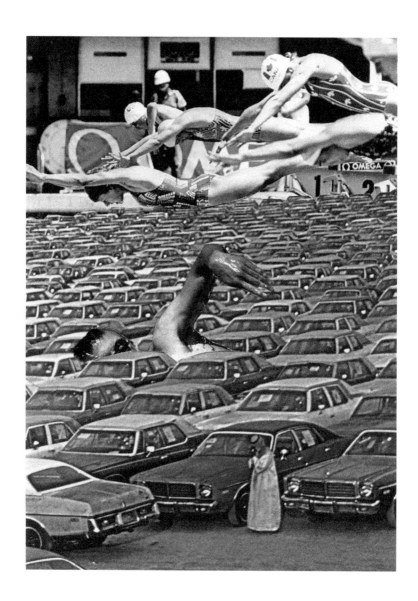

WE'RE HAVING SO MUCH FUN

hand cut photo montage, 8.070 x 11.259 inches

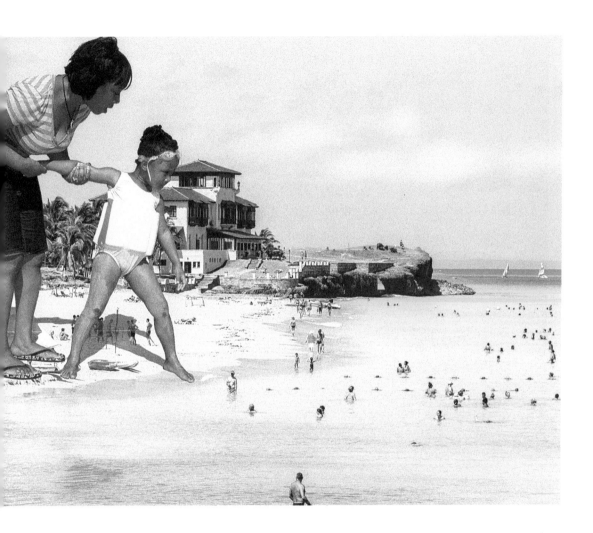

SWIMMING WITH MORE THAN FISH

digital collage, 17 x 11 inches

DUSKA VRHOVAC

BELGRADE, SERBIA

MAY BE IT EXISTS SOMEWHERE

May be it does exist somewhere

Harmony, Sense and pure Feeling

but here where you dropped me, Lord,

topluck my days, I did not find them.

In this night of white peacocks and thoughts of jade

the wind tore the notes of my melody.

My soul grew tired and my heart clenched

listening to the old signs of recognition.

Your note screeched, dear, spent

like ozone in an industrial city, unnoticeably.

The tide which rises at the thought of you

thattremour which transports me into the other,mild wind,

all of it looks like dispersed fog this night

looks like belated spring in an overgrown garden

like dying colour of a blue violet in a forest clearing

or the bud of a cultivated rose in summer drought.

If you know the words of dodolas which bypassed our land?

if you know the mute code of dew frozen in its fall

look at me and pronounce that splendid thought about happiness

which is stuck by fear in your throat for a long time.

Or, maybe, you and me, we all, are a like.

YURI ZUPANCIC

BAGNOLET, FRANCE

VALIDATION VIRUS

oil paint on microchip, 0.3 x 0.3 inches
image courtesy PRYZ Agency

MONA JEAN CEDAR

LOS ANGELES, CALIFORNIA

FINISHED

digital collage

Recent and Forthcoming Books from Three Rooms Press

FICTION

Meagan Brothers
Weird Girl and What's His Name

Ron Dakron
Hello Devilfish!

Michael T. Fournier
Hidden Wheel
Swing State

William Least Heat-Moon
Celestial Mechanics

Aimee Herman
Everything Grows

Eamon Loingsigh
Light of the Diddicoy
Exile on Bridge Street

John Marshall
The Greenfather

Aram Saroyan
Still Night in L.A.

Richard Vetere
The Writers Afterlife
Champagne and Cocaine

Julia Watts
Quiver

SHORT STORY ANTHOLOGIES

SINGLE AUTHOR

First-Person Singularities: Stories
by Robert Silverberg
with an introduction by John Scalzi

Tales from the Eternal Café: Stories
by Janet Hamill, with an introduction
by Patti Smith

Time and Time Again: Seventeen
Trips through Time
by Robert Silverberg

MULTI-AUTHOR

Dark City Lights: New York Stories
edited by Lawrence Block

Have a NYC I, II & III:
New York Short Stories;
edited by Peter Carlaftes
& Kat Georges

Crime + Music: Twenty Stories
of Music-Themed Noir
edited by Jim Fusilli

Songs of My Selfie:
An Anthology of Millennial Stories
edited by Constance Renfrow

The Obama Inheritance:
15 Stories of Conspiracy Noir
edited by Gary Phillips

This Way to the End Times:
Classic and New Stories of
the Apocalypse
edited by Robert Silverberg

MEMOIR & BIOGRAPHY

Nassrine Azimi and
Michel Wasserman
Last Boat to Yokohama:
The Life and Legacy of
Beate Sirota Gordon

William S. Burroughs & Allen Ginsberg
Don't Hide the Madness:
William S. Burroughs in Conversation
with Allen Ginsberg
edited by Steven Taylor

James Carr
BAD: The Autobiography of
James Carr

Richard Katrovas
Raising Girls in Bohemia:
Meditations of an American Father; A
Memoir in Essays

Judith Malina
Full Moon Stages:
Personal Notes from
50 Years of The Living Theatre

Phil Marcade
Punk Avenue:
Inside the New York City
Underground, 1972-1982

Stephen Spotte
My Watery Self:
Memoirs of a Marine Scientist

PHOTOGRAPHY-MEMOIR

Mike Watt
On & Off Bass

MIXED MEDIA

John S. Paul
Sign Language: A Painter's Notebook
(photography, poetry and prose)

FILM & PLAYS

Israel Horovitz
My Old Lady: Complete Stage Play
and Screenplay with an Essay on
Adaptation

Peter Carlaftes
Triumph For Rent (3 Plays)
Teatrophy (3 More Plays)

Kat Georges
Three Somebodies: Plays about Noto-
rious Dissidents

DADA

Maintenant: A Journal of
Contemporary Dada Writing & Art
(Annual, since 2008)

HUMOR

Peter Carlaftes
A Year on Facebook

TRANSLATIONS

Thomas Bernhard
On Earth and in Hell
(poems of Thomas Bernhard
with English translations by
Peter Waugh)

Patrizia Gattaceca
Isula d'Anima / Soul Island
(poems by the author
in Corsican with English
translations)

César Vallejo | Gerard Malanga
Malanga Chasing Vallejo
(selected poems of César Vallejo
with English translations
and additional notes by
Gerard Malanga)

George Wallace
EOS: Abductor of Men
(selected poems in Greek & English)

POETRY COLLECTIONS

Hala Alyan
Atrium

Peter Carlaftes
DrunkYard Dog
I Fold with the Hand I Was Dealt

Thomas Fucaloro
It Starts from the Belly and Blooms

Inheriting Craziness is Like
a Soft Halo of Light

Kat Georges
Our Lady of the Hunger

Robert Gibbons
Close to the Tree

Israel Horovitz
Heaven and Other Poems

David Lawton
Sharp Blue Stream

Jane LeCroy
Signature Play

Philip Meersman
This is Belgian Chocolate

Jane Ormerod
Recreational Vehicles on Fire
Welcome to the Museum of Cattle

Lisa Panepinto
On This Borrowed Bike

George Wallace
Poppin' Johnny

Three Rooms Press | New York, NY | Current Catalog: www.threeroomspress.com
Three Rooms Press books are distributed by PGW/Ingram: www.pgw.com